LICHFIELD IN 50 BUILDINGS

JOSS MUSGROVE KNIBB

AMBERLEY

For my dad, Brian Musgrove – a lovely man and a great writer.

First published 2016

Amberley Publishing, The Hill, Stroud
Gloucestershire GL5 4EP

www.amberley-books.com

Copyright © Joss Musgrove Knibb, 2016

The right of Joss Musgrove Knibb to be identified as the Author of this work has been asserted in accordance with the Copyrights, Designs and Patents Act 1988.

Map contains Ordnance Survey data © Crown copyright and database right [2016]

British Library Cataloguing in Publication Data.
A catalogue record for this book is available from the British Library.

ISBN 978 1 4456 5981 7 (print)
ISBN 978 1 4456 5982 4 (ebook)

Origination by Amberley Publishing.
Printed in Great Britain.

Contents

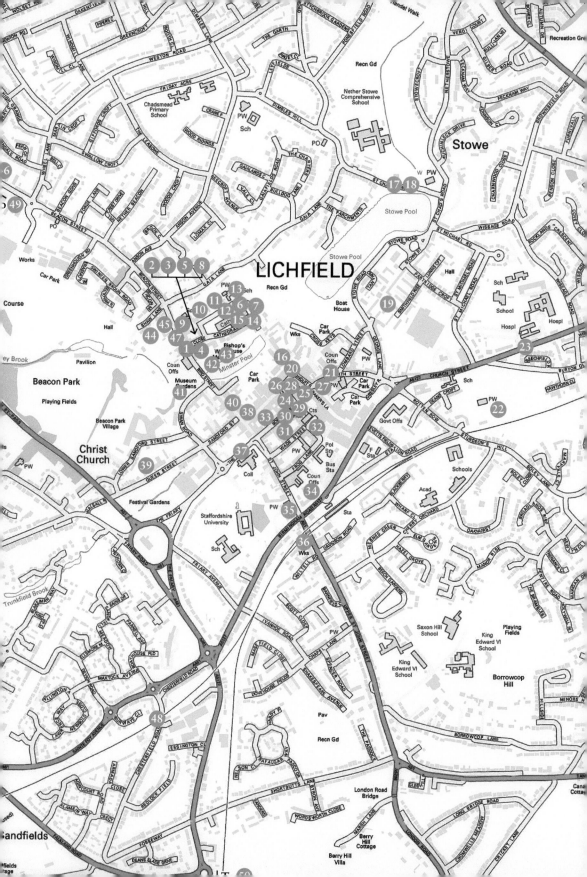

Key

A Brief Note on Reading and Using This Book

This book can be used in two ways. Reading it while sitting snugly at home will give you a virtual tour of the city, and help you get under the skin of a place that locals are still rightly proud of. It can also be used as a visitors' tour guide and will, I hope, introduce you to Romans, saints, pilgrims, philosophers and chancers while you walk through a city that's filled with light, water and beauty. To use this book as a walking tour guide, simply refer to the map. Most buildings are within a short walk of each other.

Author Terry Pratchett created a fictional universe in his *Discworld* series, and at the centre of this universe was the great city of Ankh-Morpork. What this city was built on, he observed, was in fact more Ankh-Morpork. Lichfield can make the same claim. Under each building is another building, and under that another. Our 'Russian doll' architecture makes it very difficult to precisely pinpoint the chronological date of a building's construction. Peek behind Georgian frontages and more often than not you'll find a timber-built medieval or Early Modern core.

Buildings allow us to look into the mind of those who commissioned and built them. Twelfth- and thirteenth-century medieval homes are normally set out in the most practical way possible. Church buildings are songs in stone to the glory of God and their patrons. Seventeenth-century houses speak about a growing confidence in trade. Eighteenth-century buildings are interested in light and scientific principles and nineteenth-century edifices are full of the confidence of the Industrial Revolution and empire.

This book is a walk through the growth of a city. Lichfield, perhaps more than any other city in Staffordshire, holds a beautiful collection of buildings, which are still used as churches, museums, schools, homes, offices and shops. They're still 'alive' – not frozen in amber, but still filled with Lichfeldians living their lives. Children still look through windows and shop bells still ring.

Lichfield Cathedral Close in 1906. (Postcard from the collection of David Gallagher)

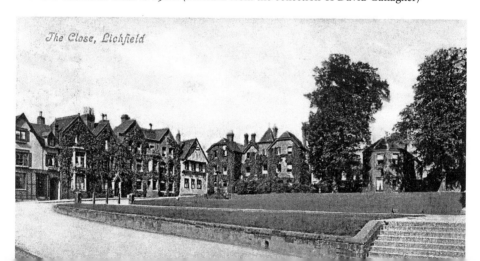

The Close, Lichfield

A Potted History of Lichfield

It's a strange name, Lichfield, and its origins are still the subject of speculation. There is a local legend that, in AD 300, the Romans massacred 999 Christians in what would become the city, and that the name can perhaps be translated as 'field of the dead'. This story is now considered apocryphal. Other explanations are less dramatic and probably closer to the truth. The place name Lichfield, could in fact be derived from '*Luitcoit*' (itself derived from the Celtic/Old Welsh words for 'grey wood') and the Anglo Saxon word '*feld*', meaning common pasture – a handy way to describe an area of pasture by the grey wood.

St Chad became Bishop of Mercia in AD 669. He established his See in Lichfield and died at Stowe (Lichfield) in AD 672. In AD 700, St Chad's remains were housed in Lichfield's first cathedral, built by Bishop Hedda on the site of the current cathedral. This church was itself a replacement of an even earlier church here. The current cathedral, dedicated to St Chad and St Mary, still attracts pilgrims, as it has done for over 1,300 years.

The Domesday Book (1086) describes what would become Lichfield as a series of small scattered settlements alongside Minster and Stowe Pools, created to provide fish for the clergy and power for several mills.

In the twelfth century, Bishop Roger de Clinton completed the construction of a new cathedral (which was again replaced by another Gothic structure in the thirteenth century). He also ordered the erection of a ditch and wall around what was now the Cathedral Close. In addition, he swept away the old Anglo-Saxon town, with its random street patterns and lack of order, and replaced it with a settlement built on a grid system. Lichfield was now becoming somewhere with greater status and affluence, and to both protect it and control access, a ditch and bank was built to protect the south side of the growing city with four gates to allow access – Culstubbe Gate, Tamworth Gate, Stowe Gate and Beacon Street Gate.

In 1153, Lichfield was granted a charter to hold a market each Sunday, the first of many market charters to be granted, and for a short period in the twelfth century Lichfield minted its own coinage.

In the late thirteenth century, under the direction of Bishop Langton, the Cathedral Close became fortified with high stone walls, towers and stone gates.

By the end of the thirteenth century, textile processing was becoming an important trade in the city. From at least the sixteenth century, leather goods were also very important to the local economy.

Plague hit the city several times in both the sixteenth and seventeenth centuries, killing over half of the population. The English Civil War, which started in 1642, killed a significantly greater proportion of the population of Britain than the First World War. It was utterly devastating, and the cathedral and Cathedral Close experienced more than its fair share of this destruction.

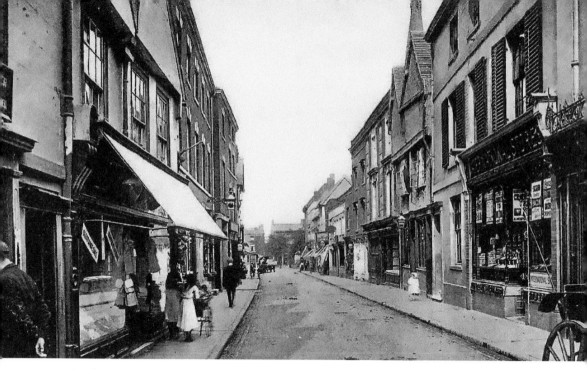

Market Street, looking down to the Market Square *c.* 1924. (Postcard from the collection of David Gallagher)

In the seventeenth and eighteenth centuries, the town became home to some of the greatest thinkers and literary personalities of their day. Dr Erasmus Darwin, Anna Seward, Elias Ashmole, David Garrick and Samuel Johnson were all born or made their home here.

In the nineteenth century, the spirit of Victorian reformers created a dispensary to provide free medicines to the poorest citizens. Streets were paved and gas lights installed when the gasworks opened in 1833.

The 1930s saw the creation of the first council houses in the city and Victoria Hospital was established in 1933. In the 1990s, Three Spires Shopping Centre opened, and in 2003 the Garrick Theatre was built. The city continues to prosper and grow.

The 50 Buildings

1. The Cathedral Close

Lichfield Cathedral sits surrounded by the charming Cathedral Close (also known as The Close), which mixes a fascinating history with some exquisite architecture. A jewel in its own right, you enter The Close either from Beacon Street or Dam Street. For the purposes of this book, we're touring The Close from the Beacon Street entrance first.

The Close was built to house and provision the clergy and laity who worked within the great cathedral. It was a self-contained world, circled both by stone walls and a ditch. This plan, of a church surrounded by homes and workshops, was in place most likely from the Anglo-Saxon period, and successive generations simply enlarged, altered and replaced the buildings. To understand the history of The Close, it's necessary to talk about the destruction that took place there during the Civil War.

The Civil War began in the year 1642. It was a fight to the death (quite literally in the case of Charles I) between the king and his Royalist followers, and Parliament and the forces of the Parliamentarians. Very few areas of the country were spared the upheavals of this nine-year conflict.

When war was declared, the town was garrisoned by Royalist forces. In 1643, Parliamentarian commander Lord Brooke moved towards the city with a force of 1,200 men. The Royalists retreated to the well-fortified cathedral and The Close. The Parliamentarians set up artillery to try to destroy the South Gate. Local legend has it that Lord Brooke was killed while peering out of the upstairs window of Brooke House (No. 24 Dam Street). A blue plaque now marks the spot. He was killed by a shot through the eye, made by 'Dumb Dyott', a deaf and mute soldier, who made this extraordinarily lucky shot (for him at least) from the spire of the cathedral. After several days of mortar fire, the Royalists surrendered. The men had their weapons confiscated and were allowed to go, although their commanders were imprisoned.

The Cathedral Close had impressive stone walls with corner towers and two fortified gates, the remains of which can still be seen. By the time of the war, the medieval city bank, ditch, and gates had fallen into disuse and were no bar to any invading force. And so in the last days of March 1643, the Parliamentarians moved into The Close and the cathedral. They tried to repair damage to the defences, but the cathedral suffered damage (soldiers were not greatly concerned with the sanctity of the building).

By early April, Royalist forces under the command of Prince Rupert had arrived to dislodge the Parliamentarians. They fired cannons at the northern side of The Close, from an area still known as Prince Rupert's Mount (now in the beer garden of the George & Dragon pub on Beacon Street). They also tried to tunnel and lay explosives underneath the defences and the Parliamentarians started their own tunnels to head them off. On 20 April, Prince Rupert's forces managed to destroy part of the walls and the Royalists entered The Close. A ferocious battle took place, with the king's men suffering high casualties. The Parliamentarians however were running low on food and ammunition and, on 21 April, they surrendered, marching away down Bird Street.

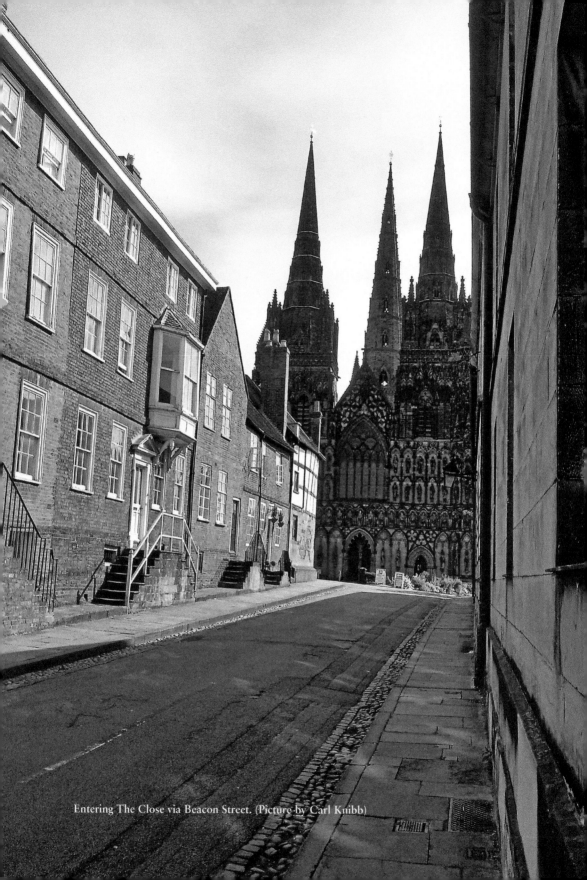

Entering The Close via Beacon Street. (Picture by Carl Knibb)

For a time, the Cathedral and Close were in Royalist hands, but extensive damage had been done to both. By the last years of the war, when the Royalists had been effectively beaten, the Parliamentarians still had to force them out of their scattered strongholds – Lichfield being one.

A final siege took place in March 1646. The Royalists inside the battered Close were well supplied, so the Parliamentarians decided to wait for a while to let their supplies of food and ammunition run down. In May, heavy artillery arrived, bombarding the cathedral and the central spire and much of the roof was destroyed. The Royalists would not surrender however until the king, realising that further resistance at this point was counterproductive, wrote to his commanders. He told them to try to come to the best surrender terms they could and, in July, 780 men marched out of The Close and laid down their arms.

Although the sieges had ended, the Parliamentarians could not allow such a strong defensive position to exist, and so they pulled down The Close's remaining stone walls and parts of the gates. Many houses on The Close, built in the years after the war, are built with incongruously large stones, recycled from the remains of these walls.

2. No. 1 The Close and West Gate

Number 1 The Close is attached to the remains of the West Gate and so would have been originally, for the most part, outside the Cathedral Close. This house was in use in 1661,

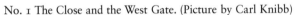

No. 1 The Close and the West Gate. (Picture by Carl Knibb)

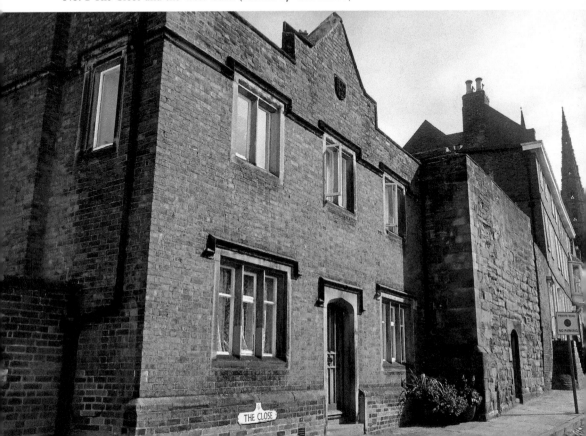

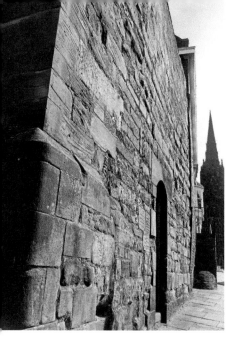

West Gate, The Close. (Picture by Carl Knibb)

and although we do not know if it was then mostly still made up of the original medieval construction, its position may have allowed it to survive the ferocious cannon and musket fire battles of the Civil War.

In 1661, a local tailor by the name of James Barrow lived here. He rented his property from the Cathedral Chapter. The majority of the houses standing in the Cathedral Close are still owned by the cathedral and chapter and are rented out to tenants, many of whom still work every day in the cathedral and diocese. Tenants include the clergy, vergers, writers and artists and The Close still retains a sense of otherworldly peace.

When Mr Barrow converted one of the original medieval dungeons under this house to a cellar, the Cathedral Chapter instructed him to excavate another dungeon with an aperture up to the street to provide light and air. This aperture may be the one visible on the Beacon Street side of No. 1. The cellars of this house retain their impressive but somewhat hair-raising atmosphere.

The current house was built in 1835, but to me this house is a puzzle, as it was built in an earlier style featuring brick-built chimney stacks, a coped gable wall, a Tudor-headed entrance over the main door and a shield showing the Diocesan coat of arms, which features the cross of St Chad.

Next door to No. 1 is the West Gate of the Cathedral Close, completed in the fourteenth century and part of the fortifications of The Close. The gatehouse has a segmental doorway and is two storeys high. The rest of the West Gate was pulled down to build Newton's College in 1800. At the same time, the road (then just 15 feet across) was widened and lowered. The gate would have been barred at night, and would have controlled traffic into and out of The Close, perhaps causing problems to the laity members of the community when popping out to one of the pubs that were common on Beacon Street.

3. Nos 2, 3 and 4 The Close

The backs of the buildings along the north side of the entrance to The Close form part of the south side of the Lower Court of Vicars Close. They're intriguing in that, in some cases,

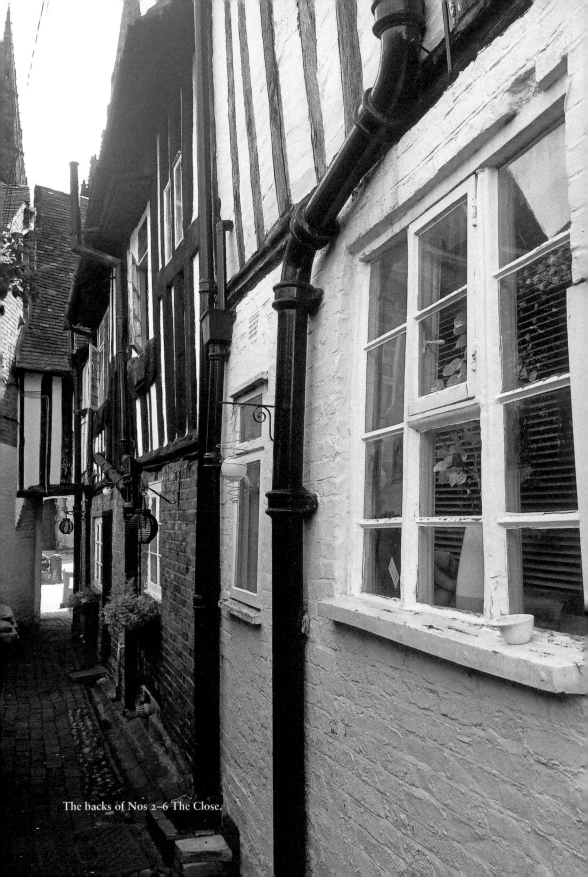

The backs of Nos 2–6 The Close.

Above: Nos 3 and 4 The Close. (Picture by Carl Knibb)

Below: Nos 2–4 The Close.

they are early eighteenth-century renovations added to much earlier buildings. Walk to the back of these houses and you can see the small doorways, leaded windows and timber construction of these earlier homes. Originally these houses faced the other way, but in the 1700s they were turned around and 'beautified'.

Numbers 2 and 3 were once one building, separated in 1720. The building is of a handsome early Georgian 'double-depth' design, with three storeys and basements, steps up to the front door and iron handrails. The steps are bowed and eroded by the passage of thousands of feet.

The doorway of No. 2 has a bracketed cornice and two pilasters, plus an original Georgian six-panelled door and the door frame of No. 3 has a moulded architrave, consoled cornicing and another beautiful Georgian front door.

Number 4 is a puzzle, as it has an impressive canted oriel window, reminiscent of the captain's quarters in a seagoing vessel, perched awkwardly right on top of the window and door below. It seems likely that whoever commissioned it was keen to see and be seen!

4. Newton's College

Newton's College was built in 1800 by architect Joseph Potter Snr to provide almshouses for the widows and unmarried daughters of members of the clergy, the first of whom took up residence in 1803. Newton's College is named after Andrew Newton, who provided £20,000 towards its creation. Mr Newton was the son of a Lichfield wine and brandy merchant and the brother of Bishop Newton. Although the front of the building is stone-faced and rather austere, the backs of these houses are brick-built and far cosier. The garden adjacent to Beacon Street was created in 1929. Newton's College is still made up of individual residences, but has not been an almshouse for the family of the clergy since the 1980s.

Newton's College. (Picture by Carl Knibb)

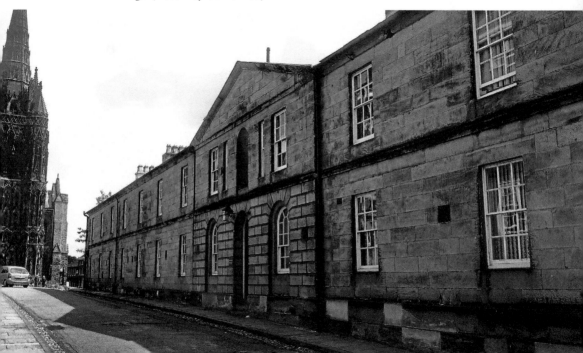

5. Nos 6 and 7 The Close

Number 6 is another half-timbered early building with an eighteenth-century brick façade, but this building follows what was probably the original medieval roofline. This building has similarities in style to Nos 2–5, with steps and handrails, but the windows are smaller with cross casements. The back of the building displays interesting brick under-building to the close-studded first floor, strengthening an ancient timber construction. This house has beautiful linen-fold panelling dating from the 1500s that originated somewhere else and was simply recycled.

It's thought that this may have been the house (although No. 8 The Close has also been suggested) where Anna Seward, the eighteenth century and rather aristocratic poet, caused rather a scandal by her close friendship with John Saville. Anna may have purchased this house for John, and he left his wife and children and moved in (despite his wife Mary's complaints to the bishop). Anna and John, her 'beloved Giovanni' would wander arm in arm, and cock a snook at their detractors. Although we can never know if this was a romantic or platonic relationship, a memorial stone in the cathedral inscribed with verses written by Anna on John's death, makes me think that this was true love, whatever form it came in.

Number 7 is a surviving example of what the front of many of the medieval houses of The Close would have looked like. It was used for many years as offices but is now in the process of being returned to a residence. The arched entrance tunnel between Nos 7 and 8

No. 6 The Close. (Picture by Carl Knibb)

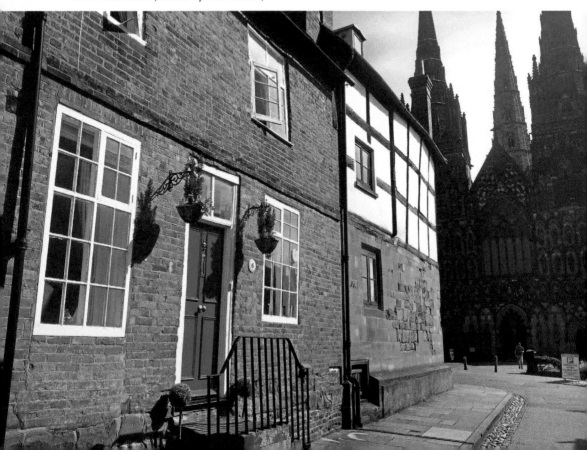

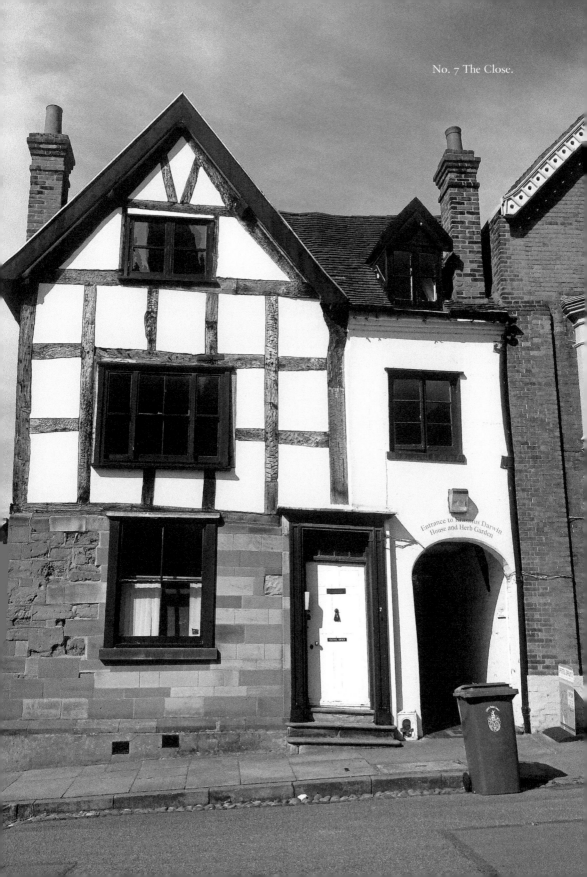

will take you through to the Lower Court of Vicars Close. If you enter the Lower Court of Vicars Close in this way, to your left are the backs of Nos 2–6 The Close, in front of you is the back of Erasmus Darwin House, and to your left are the backs of the buildings set into the south side of the Upper Court of Vicars Close (where we'll go in a moment). The gardens you are standing in are made up of the plots belonging to each house, and of the Erasmus Darwin Herb Garden. If you get lost, refer to the map. The city section of this 'tour' is designed to conclude at Erasmus Darwin House, but if you'd like to hear about it now, refer to entry No. 47 in this book.

6. Lichfield Cathedral

No visit to the City of Lichfield is complete without a tour of this exquisitely beautiful medieval cathedral. Although the spires (affectionately known as 'the ladies of the vale') can be seen as you approach the city, the cathedral itself sits, hidden, in the centre of The Cathedral Close – a square of fourteenth- to twentieth-century buildings. You come across the cathedral suddenly, making the first glimpse a jaw-dropping surprise.

The first cathedral was built in AD 700 by Bishop Hedda to house the bones of St Chad, the enigmatic first Bishop of Lichfield. Like most great medieval buildings, the cathedral is an amalgam of medieval architecture and additions from later centuries. In the twelfth

North-west view of the cathedral today. (Picture by Carl Knibb)

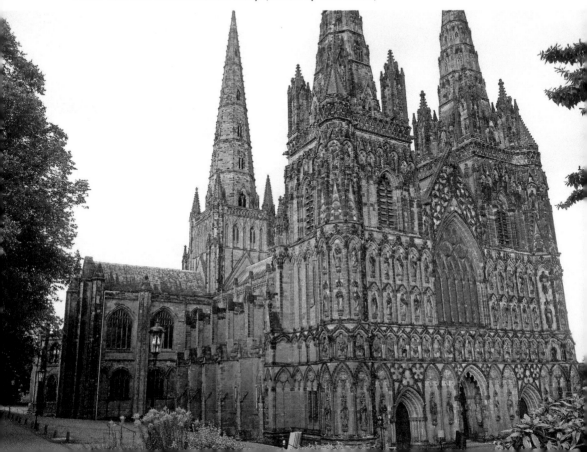

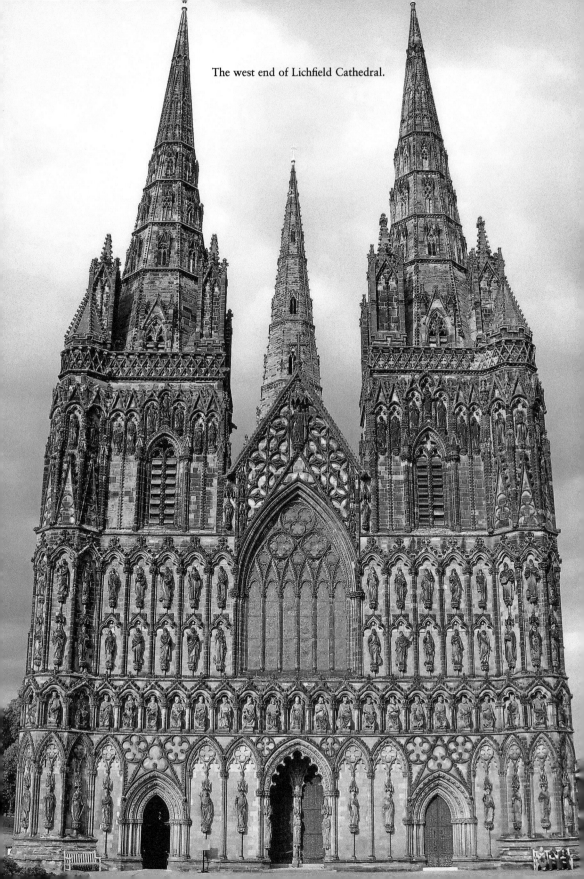

The west end of Lichfield Cathedral.

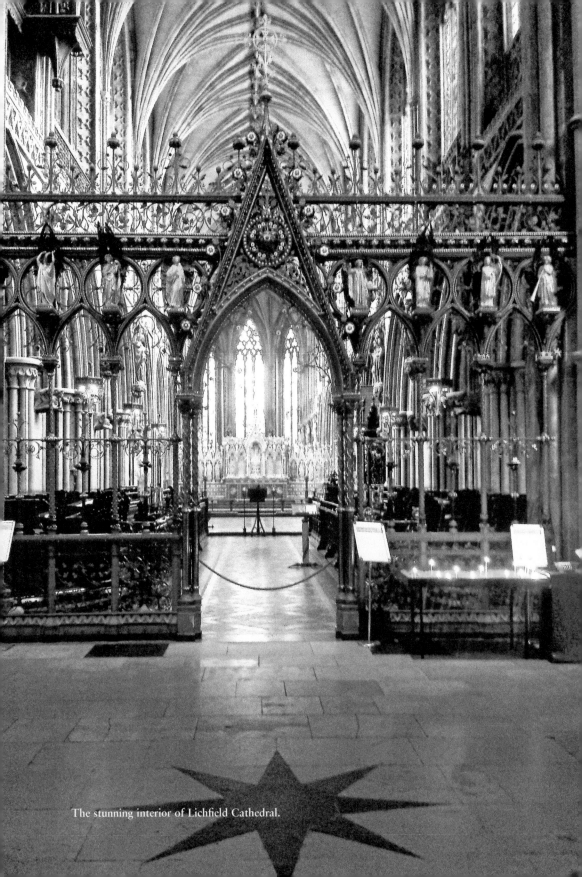

The stunning interior of Lichfield Cathedral.

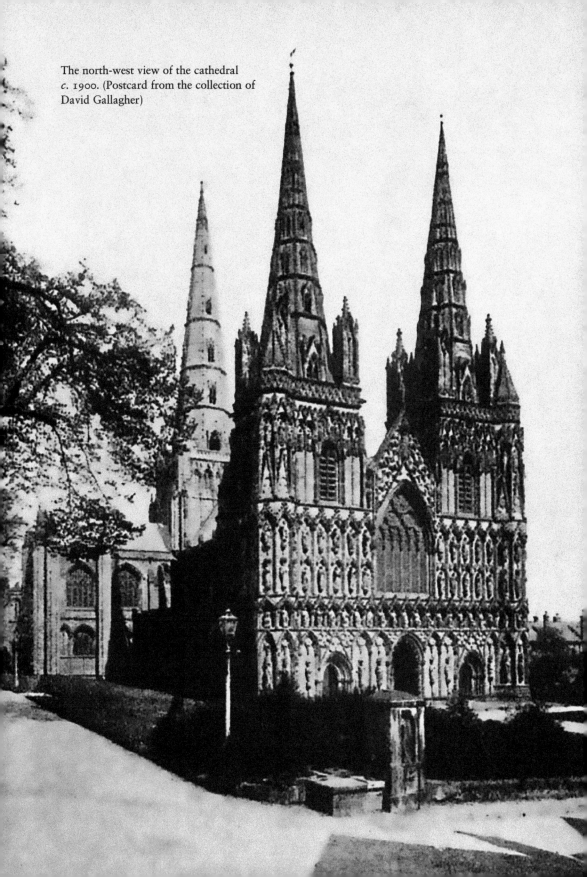

The north-west view of the cathedral
c. 1900. (Postcard from the collection of
David Gallagher)

century, the Normans replaced the Anglo-Saxon cathedral and, in the thirteenth century, it was again replaced (St Chad's Head Chapel dates from this time). The Lady chapel dates to the fourteenth century and the great shrine to St Chad (now lost) was sited here.

The west elevation of the cathedral is famous for its ranked series of statues. Throughout the Middle Ages, thousands of pilgrims made the journey to Lichfield Cathedral and pilgrims still come today to experience the beauty and spiritual regeneration that this great building offers.

During the Civil War, the cathedral suffered extensive damage. The Cathedral Close was a fortified space, with high walls, gates, towers and ditches (or dry moats). This made it the perfect spot to base the military operations of both the Royalists and Parliamentarians. During three sieges, many buildings in the Cathedral Close were destroyed. The George & Dragon pub on Beacon Street has an area of high ground in its beer garden called Price Rupert's Mount. It was here that Rupert mounted his cannons, causing terrible destruction to the fabric of the cathedral and The Close. The cathedral itself lost a spire, and the collapse of this massive structure severely damaged the roof and fabric beneath. The church was not a respected space during the war and suffered much damage. Horses were even stabled with its crumbling walls. When Charles II was restored to the throne, Bishop Hacket oversaw the restoration and, in the eighteenth century, architect James Wyatt carried out some rather contentious renovations (now removed). In 1803, the stunning Herkenrode stained glass was installed in the Lady chapel to replace that which was lost during the Reformation.

In the nineteenth century, Dean Howard instructed architect Sir George Gilbert Scott to create designs that would sweep away much of the eighteenth-century changes and restore the cathedral to a design closer to that of the Middle Ages. The cathedral holds great treasures, including the Lichfield Angel and St Chad's Gospel, both dating to the eighth century.

7. St Chad's Head Chapel

It may seem strange to separately include a mention of a chapel within the great cathedral of Lichfield, but St Chad's Head Chapel was and still is a place of high spiritual significance.

In the Middle Ages, pilgrims flocked to the cathedral to see the relics contained there. These relics are described in an 'indenture chirograph' of 1345, included in a work entitled *Collections for a History of Staffordshire 1886, Part II, Volume VI*.

The indenture chirograph describes the sacred relics that could be found at the cathedral. In the Middle Ages, relics – or sacred remnants of the bones, bodies and possessions of the saints – were considered to hold miraculous powers of healing and to be able to open up a spiritual pathway between this world and heaven.

The most important relics and the ones that attracted the greatest number of pilgrims were the bones of St Chad. The Lichfield Angel is thought to be part of the stone casket that held these relics. This casket may have been smashed by rampaging Vikings looking for treasure. It is possible that visible marks on the stone may have been left by Viking axes. The angel had been buried for centuries when it was rediscovered in 2003 while excavations were taking place in the nave.

In the mid-1300s, Chad's bones were venerated in several different shrines around the cathedral and his skull, in a painted wooden reliquary, rested in St Chad's Head Chapel (built in the thirteenth century). The main shrine to St Chad, gorgeously covered in precious

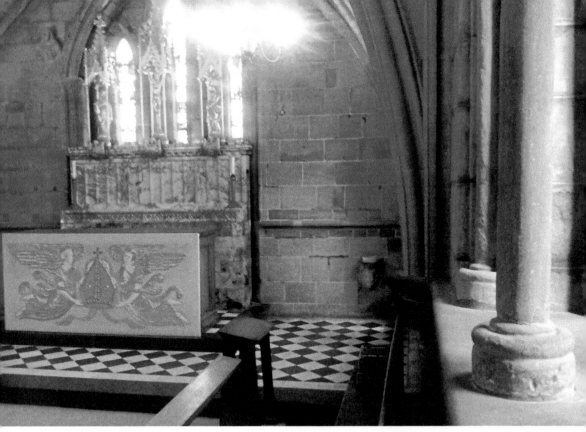

Above: St Chad's Head Chapel. (Picture by Carl Knibb)

Right: The balcony, St Chad's Head Chapel. (Picture by Carl Knibb)

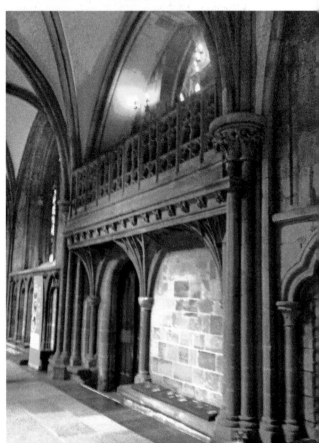

metal and jewels, stood in the Lady chapel until its destruction by iconoclasts during the Reformation.

There would have been huge numbers of pilgrims visiting the cathedral every day. To see St Chad's Head Chapel they would have used one staircase to ascend, walked around the shrine, and come down again by a second staircase that still exists. As numbers grew even more, his reliquary would have been displayed to the faithful from the balcony that also still exists.

The cathedral no longer contains the bones of St Chad that were probably smuggled out of Lichfield during the upheavals of the Reformation. It is possible that some of these bones may still exist and are now venerated in the Cathedral of St Chad in Birmingham.

8. No. 10 The Close and Conduit Pump

Number 10 probably dates to the end of the fifteenth century and has a beautiful jettied window. It is part of the lodgings originally built for the Vicars Choral. You'll see more of these lodgings in a moment in Vicars Close. Vicars Choral were, as the name suggests, employed to sing services and offices within the cathedral. They were sometimes ordained clergy and sometimes laity. In each of the buildings built for them, several Vicars Choral

No. 10 The Close.

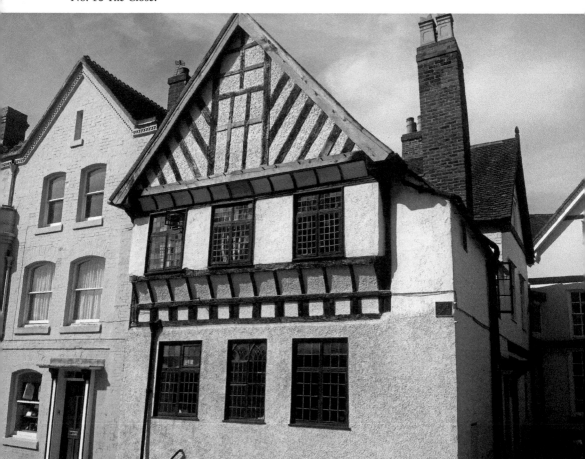

The conduit pump.

would have resided. They would have been members of the greater community of the town, going to pubs, shopping in the markets and adding their voices to the great choral services in the main cathedral.

Number 10 has some alterations dating to the 1600s, and inside there's a beautiful newel staircase and ceiling from this period.

From the twelfth century, the Cathedral Close had its own water supply, and an eighteenth-century pump and basin (probably in the same spot that the medieval pump stood) can still be seen opposite No. 10 The Close. It was used up until 1803, when the new conduit was built. This stone pump and basin is a favourite spot for local cats who like to sit in the stone basin when its old stone has been warmed by the summer sun.

9. Vicars Close

Vicars Close is a gem. It is a four-sided square built as a home for Vicars Choral in the fourteenth and fifteenth centuries, with some seventeenth-, eighteenth- and nineteenth-century additions.

Look to your right: these black-and-white houses (all still homes) are built of close-studded timber framing, many with a jettied first floor. This is the most complete range of fourteenth-century buildings.

Look ahead: this eighteenth-century building faces out on to Beacon Street.

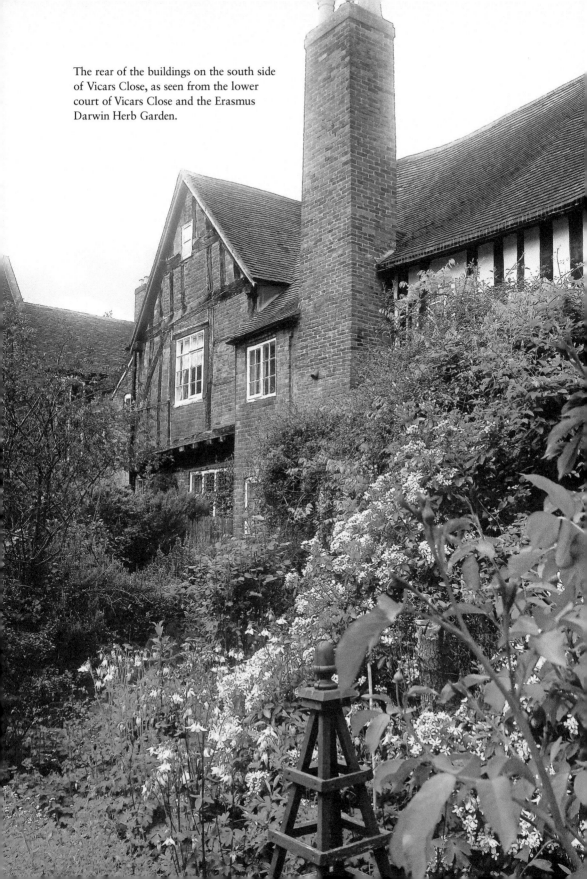

The rear of the buildings on the south side of Vicars Close, as seen from the lower court of Vicars Close and the Erasmus Darwin Herb Garden.

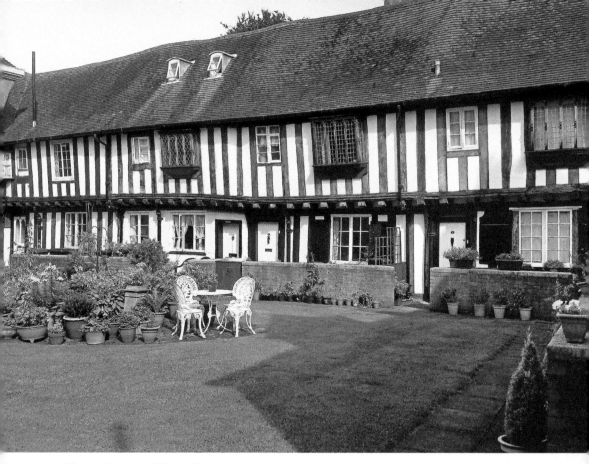

The north range of Vicars Close.

Look to your left: these buildings were damaged in the Civil War, and although from the back their medieval roots can still be seen, some have seventeenth- to nineteenth-century façades.

Inside, wattle and daub walls, heavy beams and great stone fireplaces can be seen. Many of these buildings are still home to Vicars Choral.

10. No. 12 The Close, St Chad's School House

This nineteenth-century house is part of Lichfield Cathedral School. There has been a building on this site since the early 1300s and, in the eighteenth century, this was the background to a scandal worthy of a modern talk show.

In 1774, the rather well-connected William Vyse became Prebendary of Flixon and Offley, and hence was given a house on The Close. William was married but actually became engaged to Sophia Streatfield at the same time, promising to marry her when his current wife died!

Sophia was pretty, young, bright and prone to floods of sentimental tears (perhaps a rather useful ruse to hide her intellect). William was not the first man to fall for Sophie. In 1779, Hester Thrale, a good friend of Samuel Johnson wrote that her own husband had fallen for the beguiling Sophia.

No. 12 Vicars Close.

William seems to have not liked his wife much. Telling his friends that he'd like to divorce her, or that he was looking forward to his freedom when she died. However, when his wife finally died, he passed Sophia over and married someone else.

11. The Close Conduit

For many years, I had no idea what the real use of this intriguing building was. I had been told by an elderly local that up until the 1960s it had been home to a night watchman, who, on request, would come along at the allotted time and tap on your bedroom window with a long stick to wake you up – an ancient form of a wake-up call. I suspect that this story is apocryphal, but it's a charming tale and deserves to be mentioned here.

The real purpose of this building is to house a large water tank or conduit. It was built in the 1800s and was the spot where residents and their staff would fill their water jugs from the supply piped in from local springs. Although there has been a water supply piped into The Close since the twelfth century (remarkably early in fact), this modern conduit kept water cool and clean, and was so convenient that it was still in use right up until 1969! Up until recent times, it was used as a tuck shop by Lichfield Cathedral School.

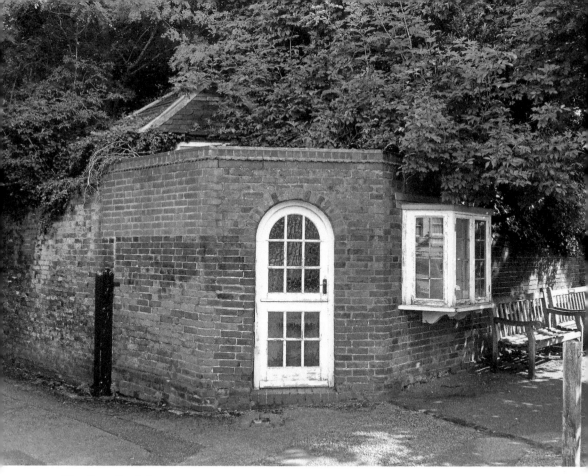

The Close Conduit.

12. The Deanery

The Deanery is, as the name suggests, home to the Dean of Lichfield Cathedral and his family. This is the charm of Cathedral Close – that buildings that were built as homes are still used as homes. It has helped these historic buildings survive intact.

The Deanery dates to 1707, but is once again on the site of a medieval house. It has been altered a little over the years, with changes made to its fabric several times in the nineteenth and twentieth centuries.

An interesting incident from the history of this house is the residence of Dr John Fell (son of the Dean of Lichfield) in the middle quarter of the seventeenth century. Just what was the problem with Dr Fell I wonder? This may be completely unfair but the children's nursery rhyme (attributed by some to Tom Brown) about him, 'I do not like thee Dr Fell', suggests that he was a difficult character:

> I do not like thee, Doctor Fell,
> The reason why, I cannot tell;
> But this I know, and know full well,
> I do not like thee, Doctor Fell.

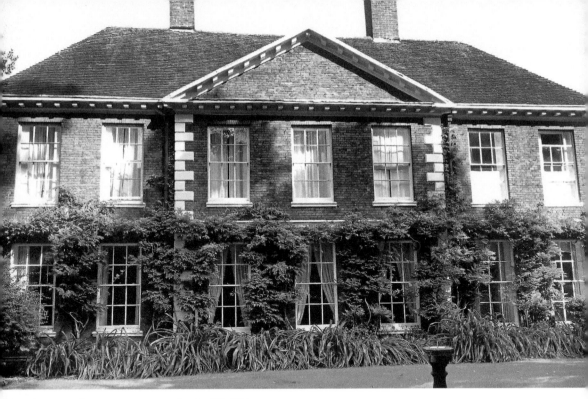

The Deanery. (Picture by Carl Knibb)

The house that Dr Fell lived in was semi-demolished during the Civil War and after this, when the number of its hearths was calculated for tax, it had only two, suggesting that very few rooms were left habitable. Dean Thomas Wood (later Bishop of Lichfield) dismantled it and had it rebuilt with much of the original materials (after the Civil War, building materials were in such short supply you used whatever came to hand), and it must have been a comfortable home to warrant a royal visit by James II in 1687.

Dean William Binckes built the new Deanery, very much as we see it today. The long southern range of the seventeenth-century house was demolished. It was in a very poor state of repair and it ruined the view from the Bishop's Palace. This beautifully symmetrical early Georgian building went through some remodelling several times in the nineteenth century and the last of the medieval outbuildings were torn down in 1967 (before they fell down).

Some of the windows have been blocked, which may have been a consequence of the notorious window tax. The window tax came in in England in 1696, and was in force for 156 years. This was a property tax based on the number of windows in your property. The assumption was that the more windows you had, the richer you were, and so home owners all over the country bricked up windows or converted them to doors.

13. The Palace

This gorgeous Queen Anne-style building was built in 1687 and was home to Gilbert Walmsley (friend of Samuel Johnson and David Garrick), poet Anna Seward and, from 1860, the Bishops of Lichfield. Since 1954, this has been a school, now known as Lichfield Cathedral School.

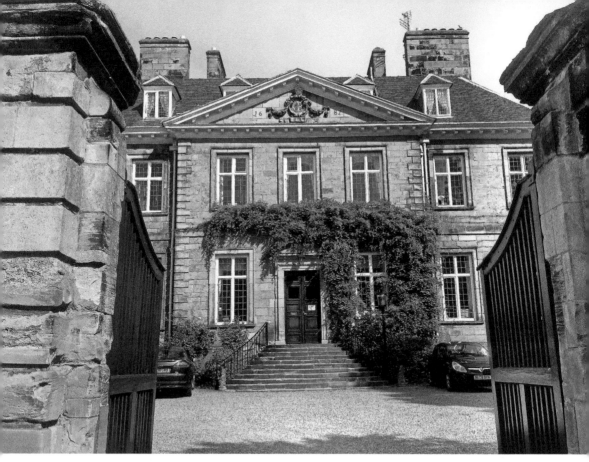

The Palace.

The on-site chapel dates to the mid-nineteenth century (it can be seen just to your left). The date on the Grecian pediment above the door is 1687. Once again, the steps to the front door have been eroded by the passage on thousands of feet. Note the Diocletian window to the right wing of the building. To the left, in addition to the chapel, are the nineteenth-century lodge and stables.

14. Selwyn House

If you peer over the wall to the left of Selwyn House, you'll see that the ground falls away sharply to the gardens below. This is because the house is built in the defensive ditch.

Selwyn House is known by locals as 'Spite House', as it was said to have been commissioned by one of three feuding sisters.

The story goes that in the 1750s three sisters each built themselves a house. The youngest sister had Selwyn House built to spoil the view of the cathedral from her siblings' grand houses across Stowe Pool. As the spinster sister, she'd had the indignity of living in her married sisters' houses and was rather looked down upon. To even the score, she built her own home in this spot, so that every time they looked at the cathedral, the first thing they saw was her. This story is now considered apocryphal, but it has so much of human nature in it I think there may just be a grain of truth.

Selwyn House. (Picture by Carl Knibb)

15. St Mary's House

From the front, St Mary's House doesn't look particularly interesting, but if you walk on past the house, through the South Gate into Dam Street and turn to your left, you'll see the remarkable history of The Close all rolled into one building.

Aspects of St Mary's House date right back to the 1200s. As you look at the house, you'll see large stones that are part of the original thirteenth- and fourteenth-century walls of The Close, and a corner turret (note the arrow slits) that also formed part of The Close's defences. It is still as sturdy and much used today as it was then. The back wall of the house is in fact part of the walls of The Close. They simply built the house into the walls – waste not want not. This house would have had a stairway to the top parapet of the walls, giving the owner a fine view of the city outside The Close and also a fine view of who was coming and going through the fortified gate next door.

The tiny windows at the back of St Mary's House may be of fourteenth-century original construction. Alterations to the interior were made in 1710 and these are commemorated by the stone above the front door.

In the nineteenth century, it became the vicarage of St Mary's Church. It was a vicarage for over a century until, in 1965, it became offices for the diocese. There are rumours of tunnels underneath St Mary's House, and this story can be added to dozens of other stories telling of secret and forgotten tunnels running underneath the city in all directions – some of which are true!

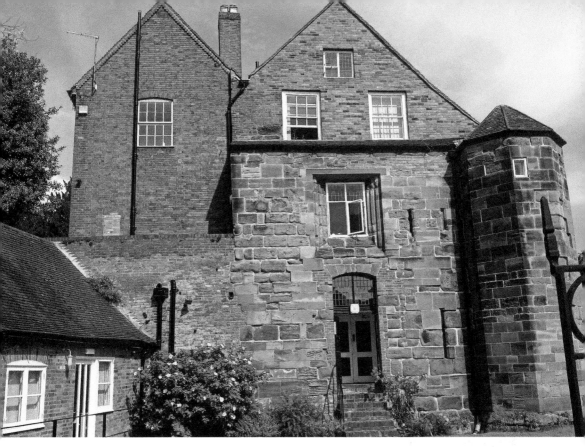

Above: South side of St Mary's House.

Below: St Mary's House front view. (Picture by Carl Knibb)

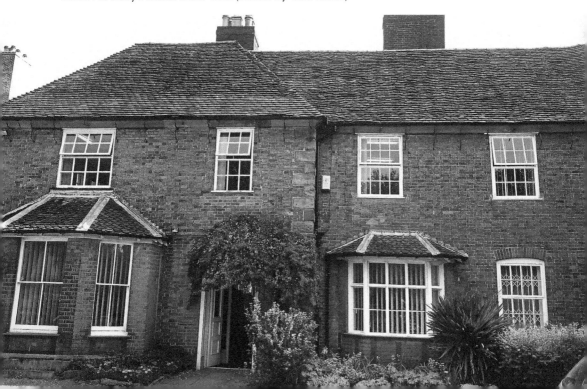

16. The South-East Gate

As we know, the cathedral sits surrounded by The Close, and The Close was ringed by high defensive walls. The Close, however, needed to trade with the city outside. Messengers and visitors needed to be greeted and checked for authenticity, horses needed to be stabled and grain stored, pilgrims needed to be allowed entry so that they could pray at the shrine of St Chad and in this small corner we have traces of much of this activity.

Opposite St Mary's House you'll see the impressive remains of the South-East Gate, with its nineteenth-century sign announcing:

<div align="center">

THE CLOSE
NOTICE

The Road through the Close
not being a Public thoroughfare
no Waggons, Carts or Cattle
are allowed to pass through.

By Order of the Dean and Chapter.

</div>

The South-East Gate.

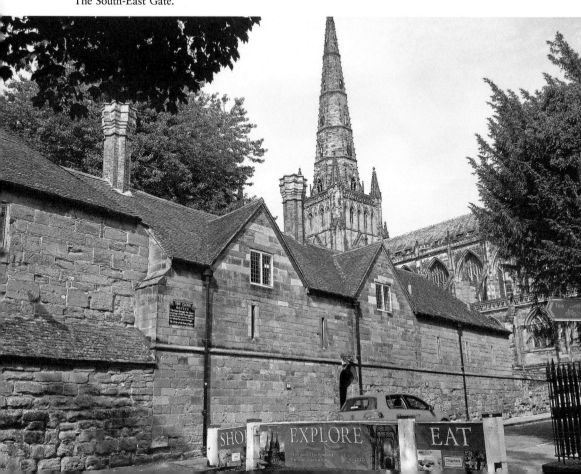

Walking away from Dam Street back on to The Close, turn left and left again and you'll be on the other side of the remains of the gate, in the area known at The Stables. This is where horses, hay and grain were stored in the seventeenth century, but you'll see large fragments of the medieval gate built into the structure. The stables are now used as a place of study. If you walk a little further forward, you'll see the Chapters opening out to your right the gardens of the cathedral tea room.

At the end of this garden is a large stretch of impressive wall. This section of wall looks, to me, almost like a wharf, with the remains of a mermaid carving next to a raised door. If visitors to the cathedral could not enter through the gate, (if the drawbridge was up or the portcullis down) and the little 'wicket gate' (a one-person gate for foot traffic) was shut up, pilgrims and visitors might need to get a boat across the water of what is now Minster Pool to enter The Close. Did they alight at this little wharf-like structure?

I was lucky enough to be given a tour of the Chapters, and went down into the cellars of this intriguing building. There, whiling away the centuries in the dark are medieval cells and ancient ovens surrounded by hooks for the hanging and smoking of meat. It's a labyrinthine world unto itself.

South Gate notice. (Picture by Carl Knibb)

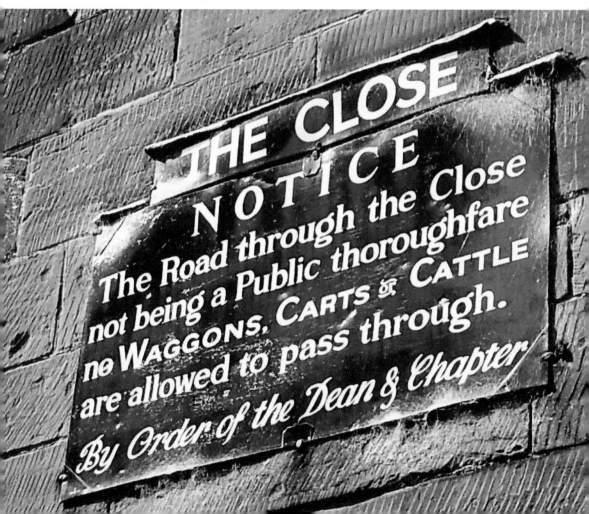

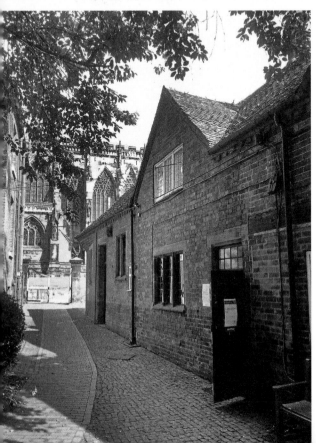

Above: The wall in the back garden of the Chapters tea room. (Picture by Carl Knibb)

Left: The area of the South Gate currently known as The Stables. (Picture by Carl Knibb)

17. St Chad's Church

Standing on the northern side of Stowe Pool, St Chad's Church is an exquisite medieval building that is wreathed in folklore. St Chad came to Lichfield in AD 669 to minister and baptise the small but growing Christian community. St Chad's Church is believed to stand in an area that, at the time of Chad, was rather watery, divided by streams and with a well of natural spring water. In an area of raised ground between these streams, he established his cell and a small monastic community. Chad and his companions could retire to this spot to pray and contemplate. It was here that he died in AD 672, and it still retains a feeling of peace and watchfulness. His remains were reinterred in Lichfield Cathedral in AD 700.

The original Saxon church on the site has left no trace, but some of the twelfth-century building remains. The lower roofline of this church and the remains of rounded Norman-era window arches can still be seen on the south wall.

When you step into the church, look to your right and walk towards the chancel. Right in front of you is a central lancet window, constructed in the thirteenth century, to your left is a fourteenth-century window and to your right a fifteenth-century window. In the stonework to the left of the fourteenth-century window there's a curious stone with odd lines carved into it. Positioned as it is, it makes no sense but if you turn it upside-down, it becomes the outline of a 'buskin-type' boot from the sixteenth century. This stone and its curious graffiti was probably elsewhere in the church and used at some point as a repair.

On the base of the right-hand (north) side of the entrance to the bell tower, you'll also see the faint traces of a medieval consecration cross, and on a column on the northern side of the aisle there is a wonderful graffito of a thirteenth-century archer.

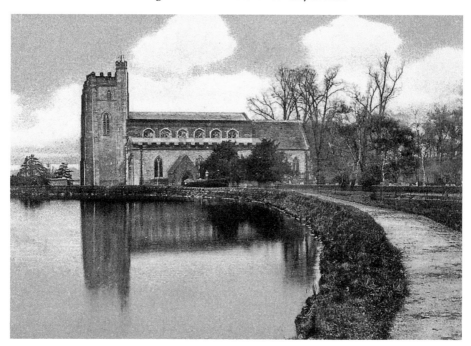

View of St Chad's Church *c.* 1900. (Postcard from the collection of David Gallagher)

St Chad's Church. (Picture by Carl Knibb)

The altar rail is from the seventeenth century. During the Civil War, St Chad's was used by Parliamentary forces to store their siege ladders and was considerably damaged by cannon ball and musket shot. The roof, in fact, was completely destroyed and was only rebuilt after the war, along with a brick clerestory. Brick was used extensively to rebuild churches in the Lichfield area, as any dressed stone available went to repair damage to the cathedral.

18. St Chad's Well

In the grounds of St Chad's Church, you'll see a curious roofed structure that looks a little bit like a small, open-sided bandstand. This is the canopy of St Chad's Well. St Bede wrote that Chad would stand, naked, at this spot to pray, balanced on a stone, and it was here that he baptised new Christians. It was Chad who built the first church here. When Chad died, it was given the name of St Chad's in his honour. The well continues to be a place of pilgrimage, and on Palm Sunday members of the congregation are sprinkled with its waters. The waters are reputed to have healing powers and, within living memory, bathing took place at this spot.

In the 1830s, a stone canopy was built over the well by James Rawson, but was demolished and replaced with the current airy structure in 1949. For many years, 'well dressing' took place at St Chad's well. This charming practise started again in 1995, but sadly the last well dressing took place in 2010.

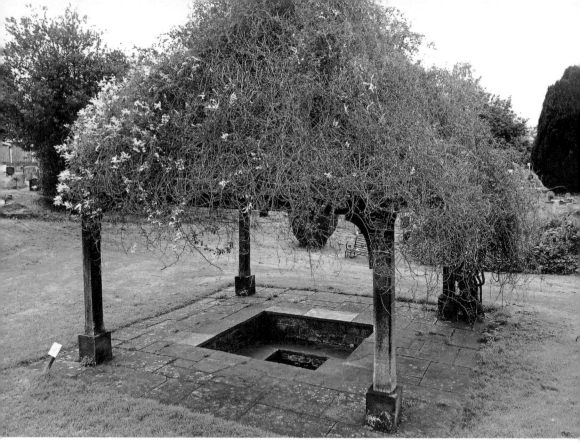

St Chad's Well. (Picture by Carl Knibb)

A local legend has it that there was (and possibly still is) a tunnel leading from the site of a pub on Beacon Street to St Chad's churchyard where the well stands, which was used by Dick Turpin and his fellow highwaymen to evade the law. It's a lovely idea that Turpin's famous horse, Black Bess, would spend evenings here, quietly cropping the lush grass in the moonlight.

19. Cruck House

Cruck House now stands in a modern housing estate and is a rare survival of a medieval cruck-built cottage from the late fifteenth or early sixteenth century. For many years, Cruck House was thought to be an ordinary brick-built Victorian cottage but, when modernisation of Stowe Street was taking place from the mid-1950s and many old buildings were being demolished, this brick exterior crumbled away and the medieval timber 'bones' of the building were discovered, luckily before the whole construction was pulled down.

Originally part of a terrace of cottages, workmen were amazed to see the old wattle and daube walls and timbers still in place, protected by a later 'skin' of brick. This rare survival is supported by jointed 'crucks' at either end. Jointed crucks are long arched beams, each side made from the trunk of one large tree.

The building was renovated in 1971 and is now used for a variety of community clubs and activities.

Cruck House. (Picture by Carl Knibb)

20. Quonians Lane

Today, when you walk down Quonians Lane, you can't fail to notice beautiful carvings, statues and decorative friezes that are pictorial traces left by the firm Robert Bridgeman & Sons, the highly acclaimed ecclesiastical stonemasons that worked from Quonians from the 1870s.

It is possible that the first timber-built house on the left of Quonians Lane is part of Ann Oliver's Dame School were Samuel Johnson was educated (see the blue plaque on the front of the brick-built frontage facing Dam Street). Although picturesque today, in the late eighteenth and early nineteenth centuries, it's likely that an open cesspit stood at the end of the lane, catching the filth that flowed down the main streets of the city.

The origins of the word 'Quonians' are wreathed in mystery. Quonians Lane (which we know was called Quoniames Lane in the early fourteenth century) might just have a connection to the Latin word '*quoniam*'. This was used as a euphemism for a woman's 'nether-regions' by the Wife of Bath in Geoffrey Chaucer's *Canterbury Tales* (written in the early years of the 1400s). Could Quonians have been a Middle Ages haunt of 'ladies of the night'?

Above: Quonians Lane.

Below: Dame Oliver's School.

21. Regal Cinema

The Regal Cinema is now the only art deco public building in Lichfield and, as you can see, is in a sadly neglected state. It opened on 18 July 18 1932, showing two films – *The Old Man*, starring Masie Gay and *The Beggar Student*, starring Shirley Dale.

The architect of this attractive building, with a mix of faux-Egyptian and art deco styles, was Harold Seymour Scott, who specialised in cinema design, also designing the Oak Cinema in Selly Oak and the Piccadilly in Sparkhill – all art deco palaces of the people.

The Regal could seat an impressive 1,300 people and included a 40-foot proscenium and café.

A string of different cinema operators took control of the Regal in the 1930s and 1940s, before the time of Associated British Cinemas who ran it from 1943 to 1969 – a time that a lot of Lichfeldians still remember with fondness.

From 1969, Bingo started to be introduced alongside film screenings and, in 1974, the cinema ceased to run as a cinema and became the Star Bingo Club.

For several years from the late 1970s, the Regal became a Kwik Save, but from 2008 has been empty and in an increasing state of dereliction. Plans to convert the building into flats and shops have been submitted but, at the time of writing this book, the Regal's future remains unclear.

The Regal Cinema. (Picture by Carl Knibb)

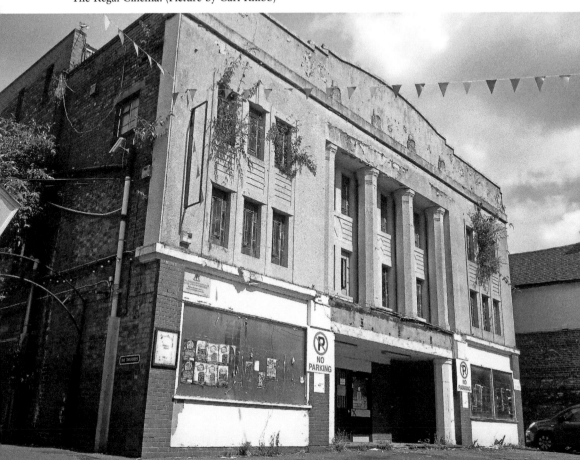

22. St Michael on Greenhill

St Michael on Greenhill sits on a high sandstone ridge overlooking the city, surrounded by a large cemetery (wooded in areas) that covers 9 acres. Although there has been a church on this site since 1190, I have been told that St Michael's churchyard may be one of the oldest burial grounds still in continuous use in the country, with burials dating from the Saxon period, or perhaps even earlier. Flints from the Mesolithic period have been found here and there are some natural springs nearby, which has led some historians to believe that this is the earliest site of occupation in Lichfield. The site of St Michael's may be the seed that the whole city grew from.

It is possible that the first church here was consecrated by St Augustine in the first years of the seventh century, and that its reputation as a holy place inspired St Chad to preach and work here a few decades later.

Much of the current church dates to the restorations that took place in 1842 and 1843, although masonry in the chancel dates to the thirteenth century. The tower is fifteenth century and the spire dates to the late sixteenth or early seventeenth century. Successive renovations took place to the fabric of the building in the nineteenth and twentieth centuries. For centuries, the churchyard was used as common grazing pasture, but now wildlife is encouraged to flourish. You'll find here the headstones and memorials of some fascinating individuals.

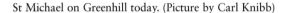

St Michael on Greenhill today. (Picture by Carl Knibb)

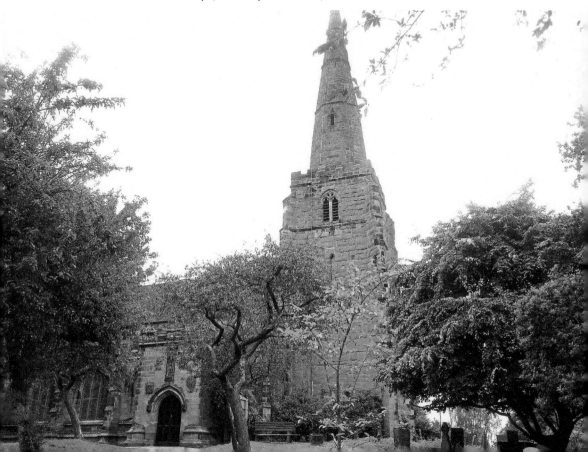

View of Lichfield from St Michael on Greenhill in 1906. (Postcard from the collection of David Gallagher)

A memorials stone reads, 'Near here is the grave of Trumpeter John Brown 1815 1898, who sounded the trumpet for the 17th Lancers at the Charge of the Light Brigade, Balaclava, 25th October, 1854.'

There are memorials here too to members of the families of both poet Philip Larkin and lexicographer Samuel Johnson. The font dates to 1669, and in the chancel you'll find the effigy of a fourteenth-century man, reputed to be a lawyer.

The last three men to be executed by hanging in Lichfield are buried in the churchyard. Convicted forgers William Wightman, James Jackson and John Neve were sentenced to hang from the Tamworth Road gallows on 1 June 1810. All three are buried in the same grave, with a marker stone that simply shows their initials.

The Grade II-listed mausoleum of Lichfield benefactor James Thomas Law stands close to the road. The path that runs close by was built to allow access to the residents of the workhouse, as they made their way to attend church services.

Also here, but unmarked, are the mass grave-pits of those who died in the ferocious outbreaks of plague that swept through Lichfield in 1593–94 and 1645–46.

23. The Workhouse

The parishes of England have always had to set up some provision, official or unofficial, for the upkeep of the poor, sick, ill and destitute and, from the late eighteenth century, this provision became formalised in the creation of those terrifying institutions – the workhouses.

The Workhouse. (Picture by Carl Knibb)

Up until the nineteenth century, Lichfield's parishes organised their own poor relief separately and in different ways – for example, employing the poor in a linen manufactory on Sandford Street. In 1836, the Lichfield Poor Law Union was set up to look after the poor of twenty-nine parishes and, on 24 May 1838, work was started on a purpose-built workhouse on Trent Valley Road. The workhouse still stands.

The bricks to construct the building were made from the red clay dug out when constructing the foundations, so it is a truly local building. It had cost £2,939 to complete when it opened its doors in 1840.

The 1881 census for residents of the Lichfield Union Workhouse shows that the oldest resident was James Dranswood, an eighty-seven-year-old shoemaker from Ireland. Its youngest residents were Percy Neville (from Lichfield) and Myra Nixon (from Burntwood) who were both just a year old. Records suggest that Percy may have been committed to the workhouse with his grandfather, or great-grandfather James Nevill (aged seventy-four). Little Myra was there on her own.

The listed occupations of the inmates are a fascinating read. They include silk velvet weavers, engine drivers and blacksmiths – skilled professions, but their ages are telling. Now in their sixties and seventies, years of hard work had taken their toll and they ended their days in the workhouse.

Over the years, buildings to treat and house the infirm were added, with the main usage of the building gradually changing from a workhouse to a hospital. In 1948, the building was renamed St Michael's Hospital. Although the site still offers medical services, it is now situated next door to Samuel Johnson Community Hospital.

24. Lichfield Market Square

In 1153, King Stephen granted the City of Lichfield the right to hold a market and this took place in Lichfield Market Square. The right to hold a market was an important one, as levies could be charged on goods coming into the city to be sold. Lichfield also held important fairs, often held on saint's days, and by the 1400s over fourteen fairs were held each year.

The market square has been witness to some very dark deeds. During the reign of the staunchly Catholic Mary I (1553–58), 280 Protestants were burned at the stake. In 1555, two men were burned in Lichfield Market Square – John Goreway and Thomas Hayward. Two years later, Joyce (or Jocasta) Lewis, also died in the market square. After a year in jail, and despite knowing exactly what her fate would be, she was executed in 1557.

Lichfield Market Square also has the dubious honour of being the place where the last execution by being burned at the stake took place in England. Edward Wightman was an Anabaptist, who was in fact burned twice. On the first occasion, he cried out and was pulled from the flames by onlookers who thought he'd recanted his beliefs after being 'well scorched'. Remarkably, once in gaol, he stood by his 'heretical' views and was finally executed at the stake in 1612. He had to be carried to the square and local authorities were concerned that the locals would riot in the face of such horror. There are plaques to these poor souls on the outer wall of St Mary's Church, facing the square.

The market square today.

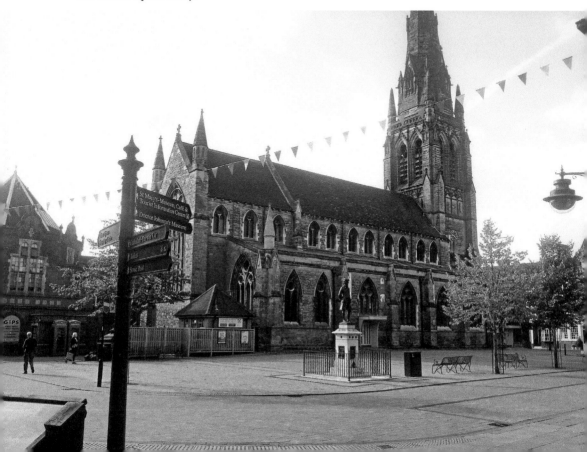

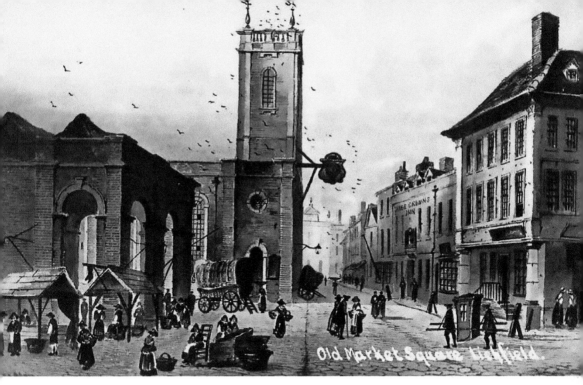

Lichfield Market Square in the eighteenth century. (Postcard from the collection of David Gallagher)

In 1651, George Fox, founder of the Society of Friends (commonly known as The Quakers) denounced the city from the market square, shouting; 'Woe unto the bloody City of Lichfield'. It seems likely that he was responding to the martyrdoms that took place here.

Back to a happier subject; the street that runs down the western side of the square is now known as 'Breadmarket Street' but was originally 'Womens Cheaping' – or the women's market where they sold their goods on market day. The square is also home to two fine statues of Samuel Johnson and his biographer James Boswell.

25. St Mary's Church

The beautiful church of St Mary's is situated in the very centre of the city and is at least the fifth church to stand here. There has been a church on this site since 1150, but a fire that swept through Lichfield in 1291 destroyed much of the fabric of this church, alongside much of the city.

St Mary's was rebuilt in 1260 and for centuries became an important civic administrative centre. In 1387, it was home to the Guild of St Mary and St John the Baptist. Medieval guilds were important bodies, made up of influential men and women of the city. Its purpose was to raise money for charity, to maintain church services and to help maintain law and order. They were also able to witness deeds and charters, making them official documents. In short, they were vital in governing the city.

This much-loved medieval church had structural issues, leading to the spire collapsing in 1594, 1626 and 1716. Enough was enough and, in 1721, a new church was built on the site.

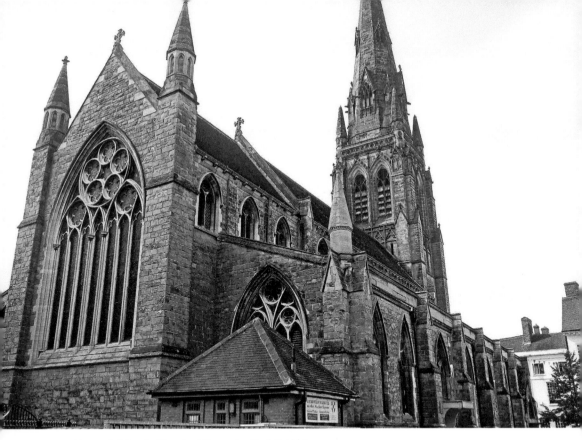

Above: St Mary's Church. (Picture by Carl Knibb)

Below: Samuel Johnson Birthplace Museum, St Mary's Church and the market square *c.* 1930s. (Postcard from the collection of David Gallagher)

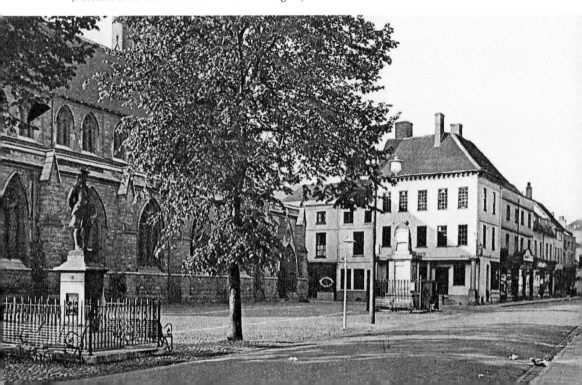

A census taken of the congregation in 1851 showed that, on average, the Sunday congregation (over several services and including Sunday school children) was 1,137. Demands for more space and a better building to suit the needs of a Victorian congregation used to greater comfort and convenience led to a third church (in the Gothic style and designed by James Fowler) to be opened in 1870. No expense was spared. Even the church organ (still in situ) was the most up-to-date available and was exhibited at the 1851 Great Exhibition. Some traces of the medieval church still exist, including the (blocked) north and south windows of the tower. The church bells date to the eighteenth century.

St Mary's in the market square is a very large building. By the mid-1960s, the population of the city centre was declining significantly. Shop owners increasingly no longer lived 'over the shop' and this and other factors had an impact on the size of the available congregation. Between 1978 and 1981, it was divided. The east end of St Mary's is still a consecrated and popular church, but the building also now contains a heritage centre, tourist information centre, gift shop, café and Lichfield Museum, carrying on the medieval tradition of St Mary's as an important civic centre.

26. Samuel Johnson Birthplace Museum

Samuel Johnson was a superstar of the eighteenth century, an essayist, novelist and playwright. He is the author of the most complete English dictionary ever seen at that point, a work of phenomenal intellectual prowess. He was born in Lichfield in the house that is now the site of the Samuel Johnson Birthplace Museum.

The house was built in 1707–08 to house the family and business of Michael and Sarah Johnson (Samuel's parents). Michael was a bookseller and his bookshop on the ground floor of the museum is still used for the same purpose today. To build his house, Michael knocked down the medieval building that stood on this site. There are beams in the roof that probably came from this earlier structure and there are records in the possession of the museum that suggest that other beams were purchased from a shipyard.

The dormer windows in the attic are in the same position as they were in Johnson's time. The layout of the main house is somewhat changed, with the original parlour and ground-floor corridor now amalgamated into the current layout.

When structural repairs were done to an interior wall in 2015, an interesting insight into the make-do-and-mend nature of a lot of Georgian building (at least where it would not be seen) was discovered when the wall was found to be filled with old floor tiles and rubble, all far earlier than the eighteenth century and possibly from the medieval building.

On Michael Johnson's death in 1731, the business was carried on by the family. A few years later, Samuel left Lichfield to make his fortune in London (accompanied by his great friend and renowned actor David Garrick), but he came home to this house regularly for the rest of his life.

After Samuel's death in 1784, the building continued to be a bookshop into the nineteenth century. As the century wore on, lots of businesses operated from this large and imposing building, including a pot-and-pan shop, a dentist's surgery, a circulating library, the offices of the *Lichfield Mercury* newspaper, Mrs Till's Coffee House (with well-aired beds!) and Miss Applebee's music school. Samuel's fame continued to grow after his death and literary 'pilgrims' would often visit, including Charles Dickens (who visited in 1840 when the house was a shop selling pots and pans).

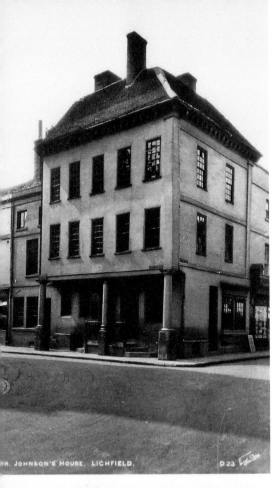

Samuel Johnson Birthplace Museum *c.* 1910.
(Postcard from the collection of David Gallagher)

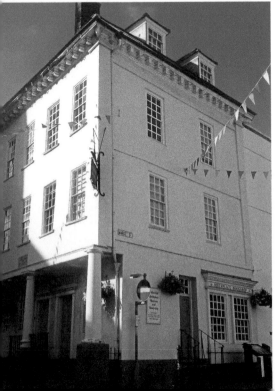

The Samuel Johnson Birthplace Museum today.
(Picture by Carl Knibb)

Samuel Johnson. (Postcard from the collection of David Gallagher)

The house was sold to James Henry Johnson in 1887. On his death in 1900, he left it to the city for a nominal amount (£200). John Gilbert, managing director of the Lichfield Brewery Co. put up the money and gifted the house back to the city.

The museum opened here in May 1901 – one of the earliest personality museums in the country. The museum is laid out to reflect as much as possible the life that Samuel would have known there and includes the family parlour, Michael Johnson's workroom and the room where Samuel was born. Samuel was baptised at St Mary's Church, just a few steps away from his front door. He was educated as a small boy at Dame Oliver's school on Dam Street and Lichfield Grammar School.

27. Boots

Boots the Chemist opened in Lichfield in 1910 in the beautiful building from which it still trades on Tamworth Street. The Arts and Crafts style building featured black beams with white plaster work and friezes featuring interesting heraldry. This traditionally styled architectural design was probably the work of M. V. Treleaven, the company's surveyor and architect, who designed buildings that would happily fit into towns and cities with a range of historic buildings.

The Boots Company started in 1849 in Nottingham, and under Jesse Boot they introduced medicines at a price affordable to most. In 1886, Jesse married Florence Row,

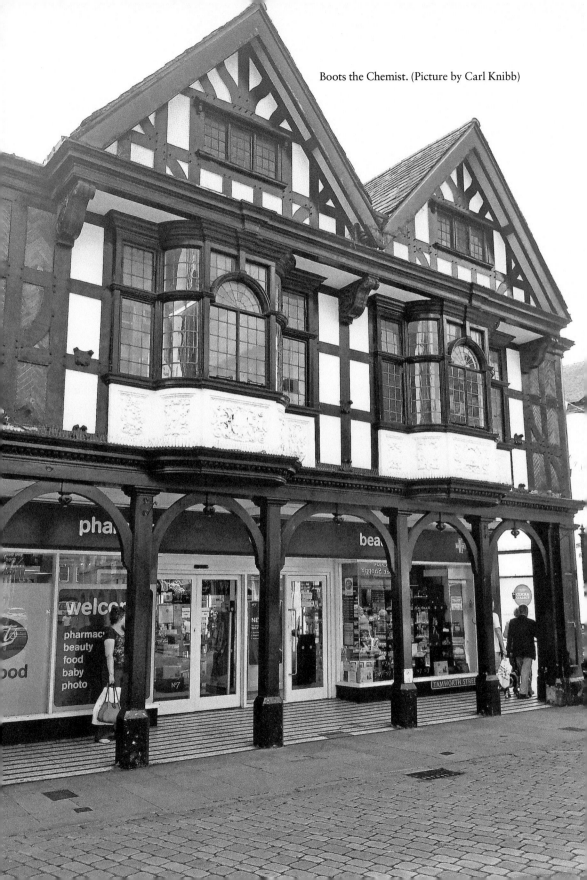

Boots the Chemist. (Picture by Carl Knibb)

whose father was a Jersey bookseller. She brought books, artists materials, picture framing and fancy goods into the store (all of which is still available in the city centre within a few hundred yards of the store).

Florence Boot was an interesting woman, who tried to improve the working lives of her female employees. Lichfield sales girls would have been entitled to a free cup of cocoa in the morning and would have had access to ladies-only healthcare. The men and women of Boots, Lichfield, would have offered a counter service only up until the late 1950s (where customers were brought their items and served over the counter).

When the First World War was declared, a call for photographs of loved-ones fighting overseas spurred Boots to go into photography – offering both studio and processing services and, between the First and Second World Wars, the No.7 cosmetics range brought affordable lipsticks and rouge to the city (no doubt to the scandal of mothers and fathers then and now).

28. The Guildhall and Guildhall Gaol Cells

The current Guildhall is at least the third building to stand on this site, and each went through successive rounds of refurbishment and renovation. The first Guildhall was erected in 1387, as a result of the recognition, by ordinance, by Richard II of the Guild of St Mary and St John the Baptist, although these guilds already had a long history by this point.

Guilds were the economic engine of medieval cities. They grouped together all of the men (and sometimes women) involved in a particular trade or business and allowed them to form a powerful body, helping them both in their personal businesses and legislating the way that business was conducted (no short measures etc.). They also had a charitable role, and it was a great thing to be appointed a member of a guild. Guilds still exist in Lichfield and they still play a vital role in the city. The Guildhall would have reflected the importance of the members and was a stone building. There are some stones from this earlier construction still to be seen at the back of the building.

In 1707, the building had fallen into such a poor state of repair, the Conduit Lands Trust gave £83 to have it pulled down and a new building erected. The trust gave another £50 in 1741 to finish the works, which, added to £100 given by Sir Lister Holt MP the year before, created a practical and useful building.

In 100 years, it was again in need of extensive refurbishment (so perhaps not the most long-lasting of constructions). In 1844, the Conduit Lands Trust donated £2,000 to put the building back in order. The Gothic arched facade that still stands today and the beautifully panelled and painted great hall date from this time. The architect of this romantic Gothic design was Joseph Potter of Pipe Hill.

The Guildhall is still used for official council meetings, weddings, events and concerts, and is owned by the City Council. In its long life it has been used for many things including a magistrate's court, police station, theatre, prison and fire station. The large double doors at the front of the building date from its time as a fire station.

We now move on to the gaol cells underneath the Guildhall. There has probably been some form of gaol in Lichfield since the twelfth century. In 1306, it was probably in the

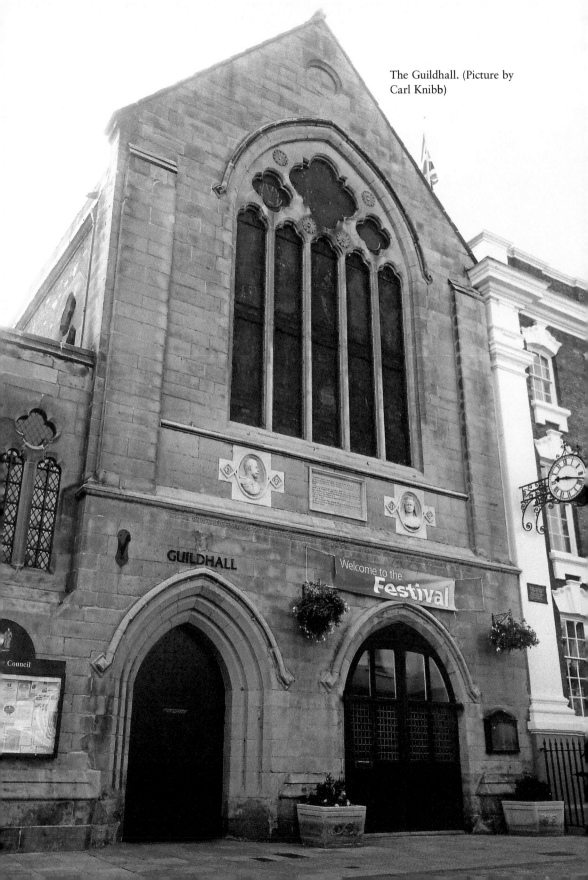

The Guildhall. (Picture by Carl Knibb)

market square. In 1459, this gaol was attacked by the Earl of Northampton, who may have been freeing Lancastrians captured during the Battle of Blore Heath – part of the Wars of the Roses. By 1548, the gaol stood in roughly the position it is now, on Bore Street (although now it now forms some of the ground floor of the Guildhall).

In 1728, a hair-raisingly awful 8-foot cage was built under 'the dungeon' (quite possibly the gaol). This is where prisoners and those under charge were kept. This would include anyone who had gotten into debt and could not pay their creditors. In 1801, the gaol consisted of fourteen cells, six day rooms and five open-air yards. The gaol was finally closed in 1866, and four cells were kept when the new Guildhall was built over them in the nineteenth century. These cells are now opened for several days every year and give a real taste of the horrors of the nineteenth-century penal system. Prisoners were often shackled and were expected to work, grinding corn and making pins.

There is a gallows to execute prisoners on London Road, last used in 1810 to hang three forgers (buried at St Michael on the Greenhill). This gallows provided fresh cadavers, some of which would have been dissected by Dr Erasmus Darwin at Erasmus Darwin House. A ghastly practise but necessary in the development of the sciences of anatomy and medicine. In the fourteenth century, there was also a ducking stool (or cuckstool) on Minster Pool, used to punish those accused of harlotry.

29. St Mary's Chambers

On St Mary's Chambers (now the premises of Ansons Solicitors) you will see a stone plaque, stating:

Priests' Hall
The Birthplace of Elias Ashmole
Windsor Herald to Charles II.
Founder of the Ashmolean Museum, Oxford.
Born 1617. Died 1692.
Educated at Lichfield Grammar School.

The story of this building goes back even further than that. As you follow this tour, you'll get the chance to glimpse the back of this building, which like so many others in the city show them to be of medieval timbered construction.

Priests' Hall was home to the Chaplains of the Guild of St Mary and St John the Baptist (formed in 1387). This guild was attached to St Mary's Church, just across the street. Parts of this hall no doubt still exist behind the brick outer-skin.

Elias Ashmole was born here in 1617. A celebrated antiquarian, academic, composer, writer and politician, Elias' insatiable curiosity allowed him to build up an extraordinary collection of artefacts and specimens. A royal appointment also came after the Restoration, when Charles II made him Windsor Herald. Ashmole's collection was donated to the University of Oxford and forms the greater part of the collection of the museum known as the Ashmolean. It was the very first university museum.

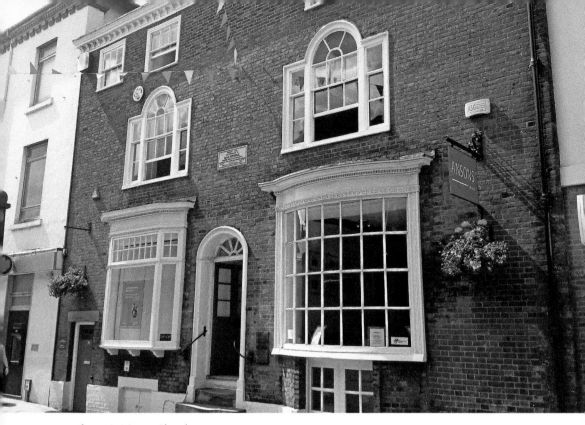

Above: St Mary's Chambers.

Below: The rear of St Mary's Chambers, showing older construction.

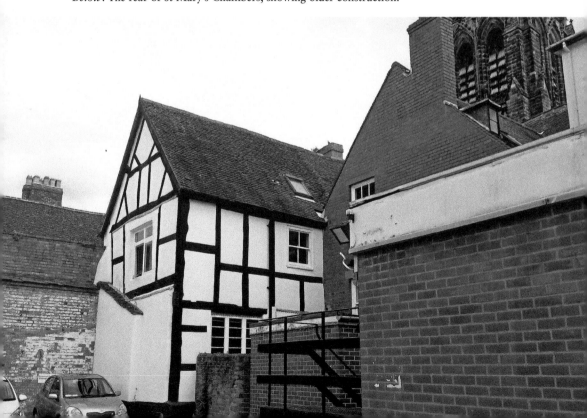

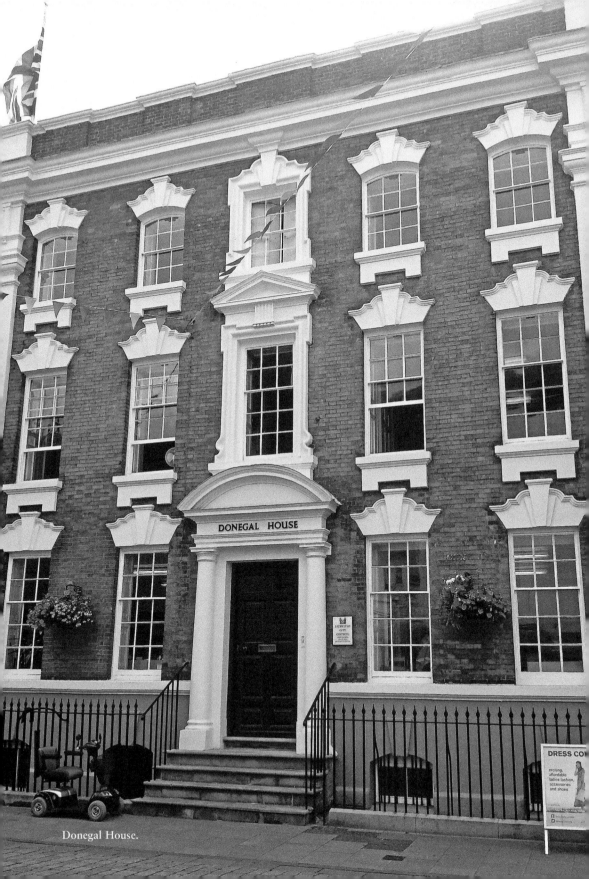

Donegal House.

30. Donegal House

Donegal House is a Grade II-listed house built to an early Georgian style in 1730. It was commissioned as a grand town house by local merchant James Robinson. It seems likely that Francis Smith, the same architect who built Trentham Hall (Stoke-on-Trent) designed Donegal House, with its symmetrical style and decorative window lintels. This is one of the finest Georgian buildings in Lichfield, and it retains an impressive period staircase and some panelling. The house was home to the Marquis of Donegal until 1799 and it is named for him. It is now home to the offices of Lichfield City Council, Lichfield Arts and the Lichfield Festival.

31. The Tudor of Lichfield

The Tudor of Lichfield Tea House, situated at Lichfield House, was built in 1510 during the reign of Henry VIII. This beautiful, Grade II*-listed, black-and-white timbered building, with later Georgian additions, holds an impressive oak stairway, oak panelling and original fireplaces, including some with Dutch Delft tiling. On the second floor there is a priest's hole. The vast cellars are mostly vaulted and may well have been used to imprison both Royalist and Parliamentarian soldiers during the Civil War. Fascinating graffiti on the

The Tudor of Lichfield today.

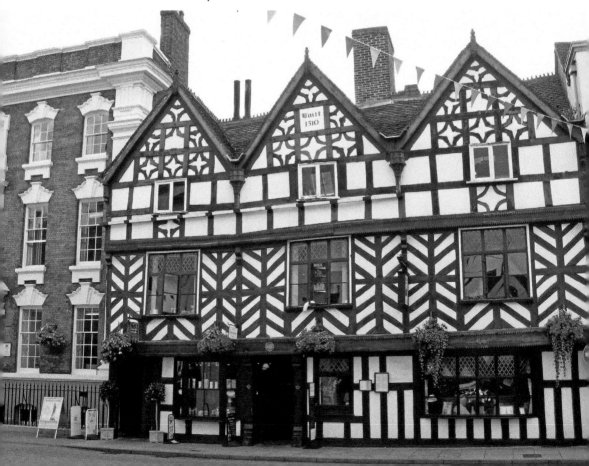

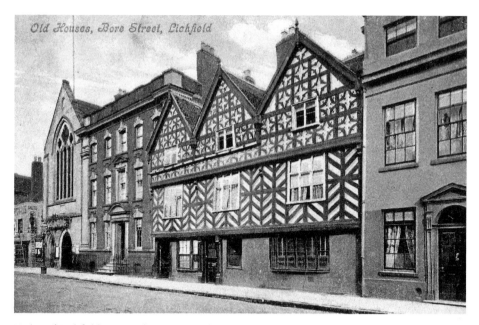

Tudor of Lichfield, Donegal House and the Guildhall *c.* 1920s. (Postcard from the collection of David Gallagher)

doors of what may have been a dungeon in the cellar include what is believed to be the name 'John Hampden' (a Parliamentary general). Scratched into the doors are the words 'Ye Gode be with us' and images of a hanged man.

A tunnel from the cellars is thought to run across the city to the cathedral. This may have been constructed during the Civil War, or perhaps during one of the outbreaks of plague that ravaged the city in the seventeenth century.

A private residence for many years, it later became the offices of the Army Pay Corps. The building has also been an antique shop, a milliners and the offices of a coal merchant. It was also used as a public air-raid shelter during the Second World War, sheltering seventy-seven people.

On the 1st September 1936, Wilfred and Evelyn Burns-Mace, alongside their son Jeffrey, opened The Tudor Café. In 1980, the Tudor Row shopping alley was built in the gardens behind the old house. The Tudor of Lichfield is still owned and run by members of the same family.

32. Lichfield Garrick Theatre

The Lichfield Garrick theatre (named for Lichfield son and renowned eighteenth-century actor David Garrick) opened its doors in July 2003 in an area known as Castle Dyke. Costing £5.5 million to construct, its modernist design was created by architect Alan Short of Short & Associates. In 2004, it was the awarded the CIBSE Project of the Year. The theatre holds two stages: the Main Auditorium and the Studio.

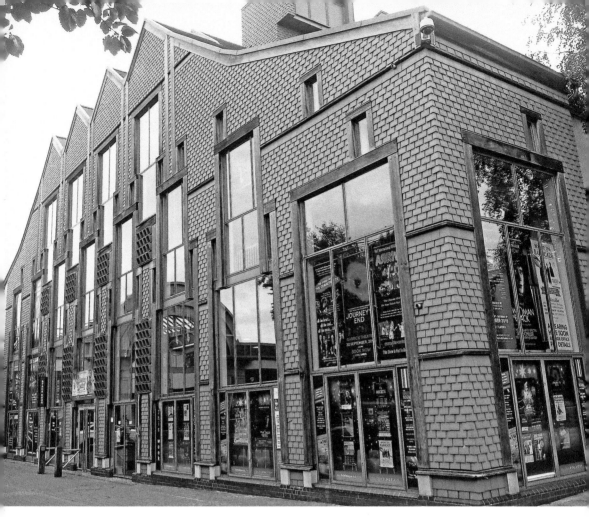

The Lichfield Garrick Theatre. (Picture by Carl Knibb)

33. Salloways Jewellers

Lichfield is a city built upon the church and trade and many local businesses have been run by members of the same (sometimes extended) family for decades. It's likely that there has been a shop or retail endeavour on this site (Nos 23 and 25 Bore Street) since the Middle Ages.

There has been a watchmaker and jeweller on the site occupied by Salloways since the mid-nineteenth century, when the business was run by Charles Thorneloe. Later, John Salloway (who had been apprenticed to Mr Thorneloe in 1861) and his wife Hannah took over when Charles died. In 1900, the business was taken over by William Salloway on John's death. The current owners are direct descendants of William Salloway.

Before the Salloway family took over both Nos 23 and 25, No. 23 was an inn known as the Woolpack. An alley to the left of the shop frontage is a remnant of those days and is where dray horses would bring barrels of beer and spirits round to the yard at the back of the pub.

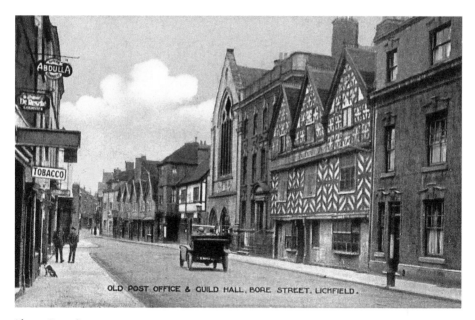

OLD POST OFFICE & GUILD HALL, BORE STREET, LICHFIELD.

Above: Bore Street, *c.* 1920s.

Below: Salloways today.

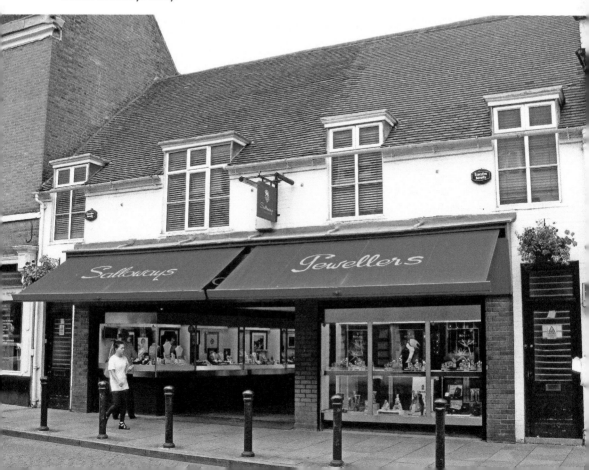

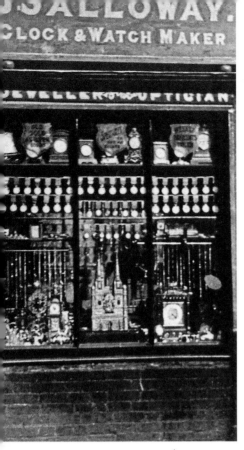

Above left: Salloways in 1884.

Above right: The alley once used to deliver barrels to the pub that stood next door.

34. Lichfield Grammar School

Lichfield Grammar School (built in 1682) and School Master's House stand, fronted by pretty gardens (that were once a playground), on Upper St John Street. There has been a school on this site since the late fifteenth century. In 1682, the Jacobean Grammar School and schoolmaster's house was built.

Lichfield Grammar School enjoyed an excellent reputation. Samuel Johnson, David Garrick and Elias Ashmole, creator of the famous Ashmolean museum, were all educated here. The school eventually closed in the early twentieth century.

Since 1919, both buildings have been used by Lichfield District Council (and its antecedents) as a council chamber and chief executive's office.

A bronze plaque on the garden wall reads:

This carriage-drive stands on the site of the moat which Bishop Roger De Clinton (1129-1148) made around the city. Some centuries afterwards it was used as the public tip and when filled up became a road called Castle Ditch which was closed in 1849 on the erection of the third grammar school. The front of this wall is the boundary between the parishes of St Mary and St Michael.

Above: The seventeenth-century school.

Below: The schoolmaster's house.

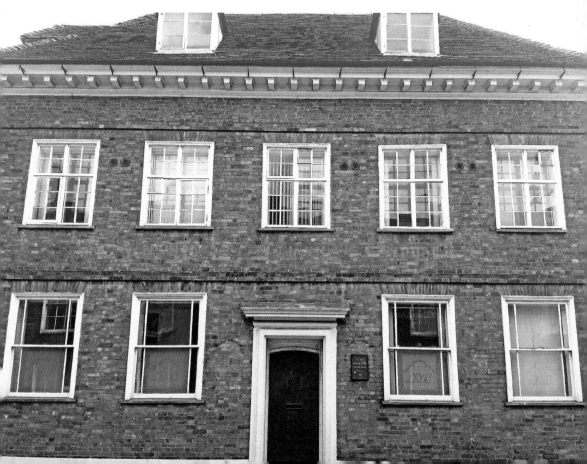

35. Hospital of St John the Baptist without the Barrs

Medieval people travelled. The very poorest might only travel a handful of miles away from their homes and obligations, but anyone who could, would take the opportunity to travel to markets and fairs that might be held 20 or 30 miles away. Going on a pilgrimage to visit shrines and relics all over the country and even to far-flung places such as Paris or Jerusalem was very popular. In the medieval period, the shrine of St Chad at the Lichfield Cathedral attracted thousands of people to the city every year. The city then was walled, with only four ways in via guarded gates or *barrs*. Once these *barrs* were closed at night, road-weary travellers and pilgrims would have to bed down wherever they could, often in the open air, and prey to thieves and attackers. To remedy this, Bishop de Clinton built a priory just outside the Culstubbe Gate in 1135, which stood on the main road from London. The priory and its Augustinian canons were able to offer safe accommodation and food to travellers in the Hospital of St John the Baptist without the Barrs. The word 'hospital' did not then have the same connotations as it does now, it simply meant a place

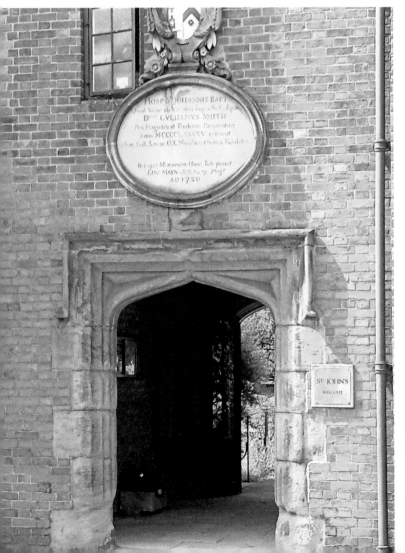

The ancient entranceway of St John's without the Barrs.

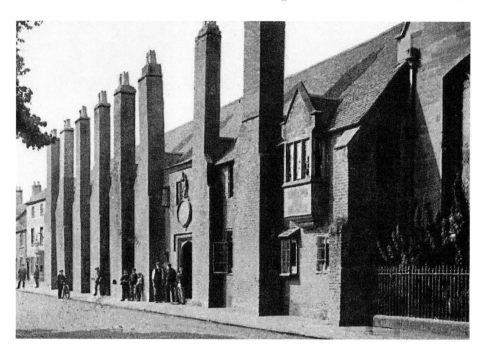

Above: St John without the Barrs in the nineteenth century. (Postcard from the collection of David Gallagher)

Below: St John without the Barrs.

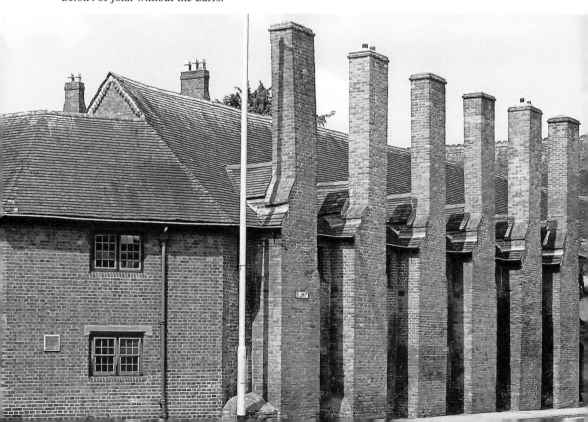

that offered shelter or hospitality, although those that fell ill would also have had access to free medical care. Poignant proof of this was recently discovered when a small graveyard was unearthed in the grounds of St John's, filled with the bodies of those who fell ill on their journey and died tragically close to reaching the shrine of St Chad. Many of those travelling would have been seeking a miraculous cure of their ill health.

The Hospital of St John the Baptist without the Barrs consisted of a stone building housing the canons and prior, plus tables and sleeping space for the pilgrims and travellers. The medieval chapel was on the same site as the current chapel.

By the late fifteenth century, the walls and ditches were falling into disrepair and the gates were left open at night. In 1495, Bishop Smythe refounded St John's as a free grammar school and home for elderly men. Bishop Smythe decreed that St John's without the Barrs would now be home to 'thirteen honest poor men upon whom the inconveniences of old age and poverty, without any fault of their own, had fallen'. These 'deserving poor' would also receive seven pence a week and were expected to attend church services every day and to be devout and of good character. A new building, or almshouse, was erected, with eight chimneys. This is the same building that can be seen today running alongside St John's Street. Today, St John's still offers accommodation to elderly men and women, almost 900 years after its first formation.

36. Lichfield Brewery

Enjoying a pint at the end of a working day has been a much-loved tradition for centuries and, in fact, the anti-alcohol prohibition movement of the nineteenth century caused malnutrition in the working poor, as beer played a vital part in their diet.

Lichfield in the medieval period would have had several brewhouses, where ale was brewed and served on site – sometime as a business and sometimes by an ordinary householder looking to augment their income. Before the introduction of hops from the Netherlands (hops preserve and flavour ale, turning it into beer), ale could not be kept for long without spoiling, and so a green, leafy branch or bush would be suspended outside the house at the time that the ale was ready. If the bough was fresh, the ale would be too. If the bough looked a bit wilted, your ale might well be sour and on the turn.

In 1869, two Lichfield breweries got together and formed Lichfield Brewery Co., which offered pale and light pale ales, strong ales, mild ales, stout and porter (a popular Victorian beer a little like Guinness) plus red and white Harvest Burgundy wine and Tintara wines, which must have been imported from Australia.

In 1930, the company was bought by Samuel Allsopp & Co. and, sadly, production at the Lichfield Brewery stopped. The brewery's story doesn't end there. Just one year later, Lichfield Aerated Water Co. moved into the brewery buildings (the craze for fizzy water perhaps coming from the 'keep young and beautiful' health awareness that grew in the 1920s and 1930s) and after this Burrows and Sturgess came on site and started to make soft drinks. Later, Birmingham Chemical Co. sat up shop on the same site.

Although most of the site was demolished in 1969, the brewery offices are still standing. If you look closely, there is a memorial on the front of the building commemorating the thirteen brewery employees who died in the First World War.

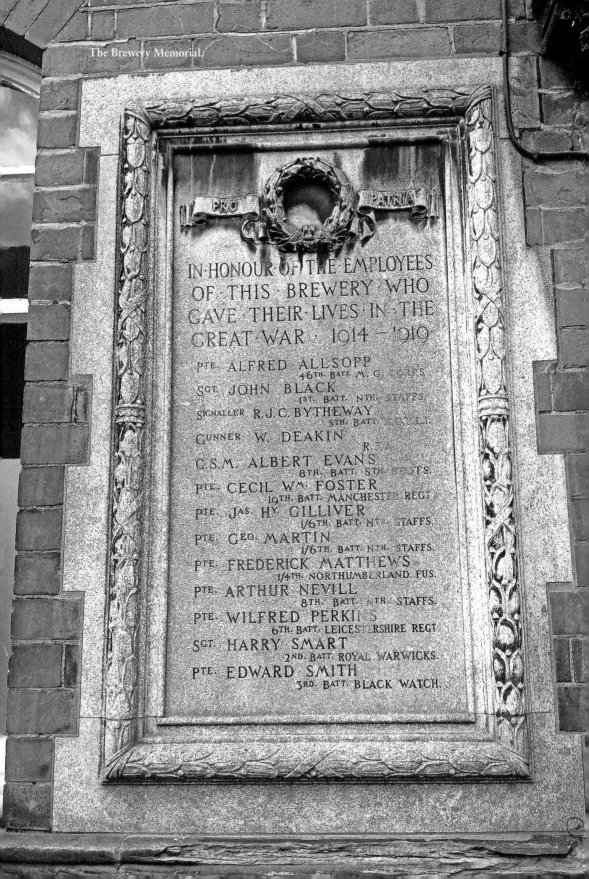

PRO — PATRIA

IN·HONOUR·OF·THE·EMPLOYEES
OF·THIS·BREWERY·WHO
GAVE·THEIR·LIVES·IN·THE
GREAT·WAR · 1914 – 1919

PTE. ALFRED ALLSOPP
46TH. BATT. M.G. CORPS.

SGT. JOHN BLACK
1ST. BATT. NTH. STAFFS.

SIGNALLER R.J.C. BYTHEWAY
5TH. BATT. K.S.L.I.

GUNNER W. DEAKIN
R.F.A.

C.S.M. ALBERT EVANS
8TH. BATT. STH. STAFFS.

PTE. CECIL WM. FOSTER
19TH. BATT. MANCHESTER REGT.

PTE. JAS. HY. GILLIVER
1/6TH. BATT. NTH. STAFFS.

PTE. GEO. MARTIN
1/6TH. BATT. NTH. STAFFS.

PTE. FREDERICK MATTHEWS
1/4TH. NORTHUMBERLAND FUS.

PTE. ARTHUR NEVILL
8TH. BATT. NTH. STAFFS.

PTE. WILFRED PERKINS
6TH. BATT. LEICESTERSHIRE REGT.

SGT. HARRY SMART
2ND. BATT. ROYAL WARWICKS.

PTE. EDWARD SMITH
3RD. BATT. BLACK WATCH.

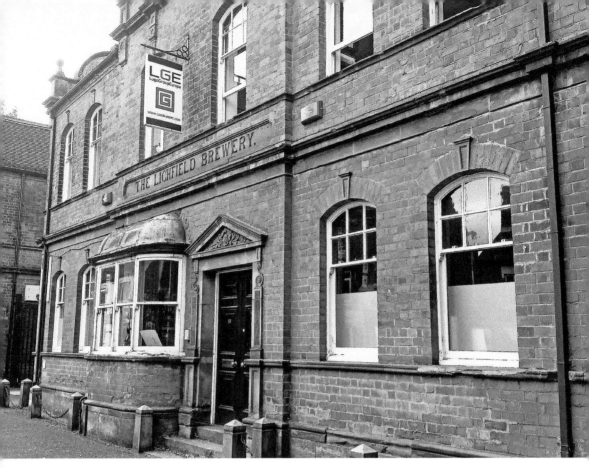

Lichfield Brewery.

37. Lichfield Friary and Bishop's Lodging

The area of the city known as 'The Friary' is, as the name suggests, the site of a large Franciscan friary built in 1237. The Friary flourished for just over 300 years, when it fell prey to Henry VIII's Dissolution of the Monasteries. Franciscans wore grey habits and they became known in the city as the 'Grey Friars'. The ferocious fire that destroyed St Mary's and much of the city in 1291 also burnt down much of the friary, but it was rebuilt, covering 12 acres and including a large church, cloisters, refectory, dormitory and hospital where the old and infirm were cared for.

The friary was sold for £68 in 1538 and most of the stone buildings were taken down, their materials sold on for profit. Only the building known as 'The Bishop's Lodging' remains and now forms part of building that, at the time of writing, houses Lichfield Library. The Bishop's Lodging is in the process of being converted into apartments.

Opposite the library is a small park, entered via a canopied portico that is the site of a 1933 excavation of some of the medieval friary site. This park is now a schedule ancient monument.

In 2015, several boxes of medieval tiles were found hidden at the back of one of the gaol cells under the guildhall. They have now been positively identified as coming from The Friary and may well have been excavated during the 1933 dig.

Above: The Bishop's Lodgings today.

Below: The Friary's gardens.

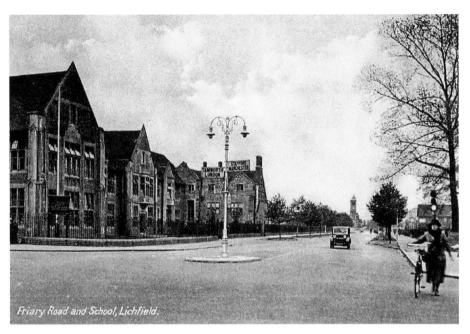

Friary Road and School, Lichfield.

View of the library and Bishop's Lodgings *c.* 1920s. (Postcard from the collection of David Gallagher)

38. The George Hotel

The George Hotel (part of the Best Western group), like so many buildings in Lichfield, is still used for the same purpose that it was constructed. Named in honour of St George, the first written account of the hotel dates to 1707 when George Farquhar, playwright and author of *The Beaux' Stratagem* wrote about this stay.

The George played an important part in the life of the city and still has one of the best preserved Regency assembly rooms in the country. In the eighteenth century, the George was an important coaching inn. Coaching inns were busy, noisy, hives of activity. Here, people would meet, eat, drink and exchange news. Passengers of the coaches often had only a handful of minutes to bolt down a little food and drink and answer any calls of nature. It would have been non-stop morning, noon and night. The arch that the coaches would have rattled through still exists, and is now the main entrance on Bird Street. In the eighteenth and nineteenth centuries, local politicians electioneered from a balcony over this archway. The George was known as pro-Whig (or Liberal) and The Swan opposite was pro-Tory. Debates often got ugly, with fighting and broken windows reported in 1826.

In the nineteenth century, the railway came to Lichfield and the horse-drawn coach traffic dwindled away. The George then became a hotel in the modern sense, rather than a coaching inn. It is still a popular venue to stay and dine.

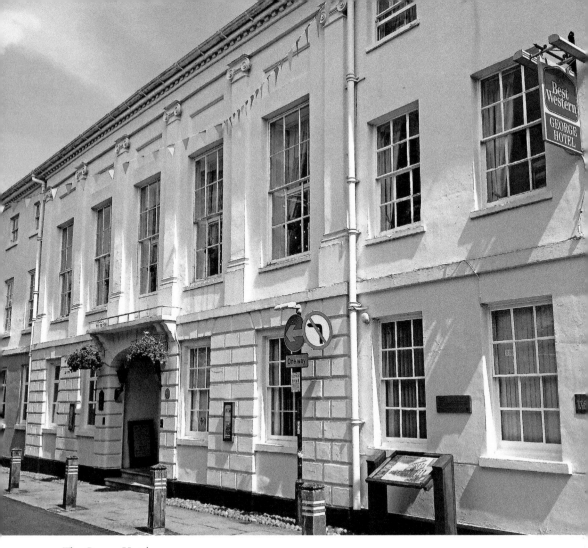

The George Hotel.

39. Alexandra House

The Police Mutual Assurance society was created in 1922. The society was set up to look after the investments, insurance and savings of serving and retired police officers and staff, and their families. The head office of the Police Mutual Assurance Building in Lichfield – Alexandra House – is a beautiful, modernist construction, built by F. and E. V. Linford of Cannock on the site that was previously occupied by Lichfield's Gas Works. Construction work started in 1969 and, in 1970, the society transferred its staff from its old offices in Edgbaston. The building was officially opened by Princess Alexandra on 24 March 1970 where she was greeted by 2,000 local school pupils and the Junior Soldiers' Company band. The new head office was named Alexandra House in her honour, and in 1972 Lichfield Civic Society presented it with an award for 'best new building'. Extensions to the building were added in 1990 and 2000.

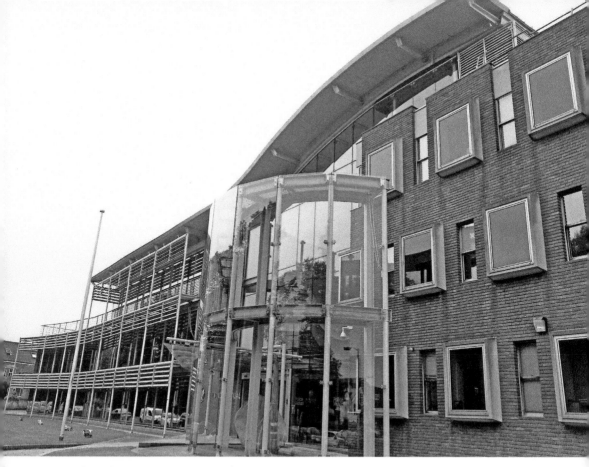

Alexandra House. (Picture by Carl Knibb)

40. The King's Head

The King's Head is a Georgian-fronted pub that hides a fascinating medieval history. There has been a pub on this site since at least 1495, when it was known as The Antelope, and later as The Bush. By 1694, it had become the King's Head. It is known as a regimental pub, where Staffordshire Regiment veterans and members of the Regimental Associations regularly meet.

It has been associated with the regiment since its very beginnings, which took place here on 25 March 1705 when Colonel Lillingston's 38th Regiment of Foot was first raised by William Henry Paget to fight in France.

The pub, as it stands, is mainly of eighteenth-century construction, with some nineteenth-century additions, although aspects of the medieval building plan remain. For many years it served as a coaching inn. The 1828–29 Pigot's Directory states that the *Herald* (the name of the coach) called at the King's Head every morning except Monday at half past two in the morning! To get to Manchester, travellers could get the *Herald* coach every day (except Monday) at the King's Head at 9am – a far more sensible time.

There are several ghost stories attached to the King's Head, including the spectre of a maid who died by fire and a terribly wounded laughing Royalist soldier who is seen walking the street outside the pub.

The King's Head pub.

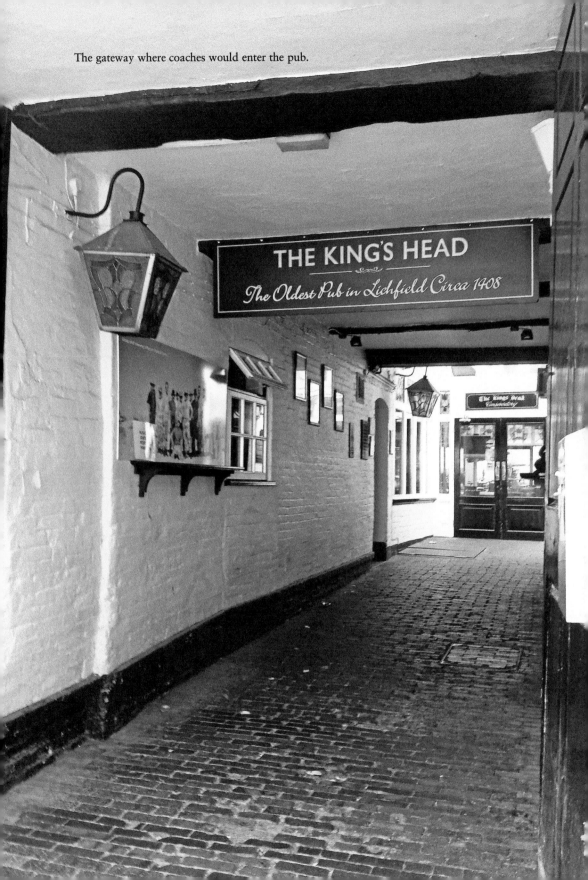

The gateway where coaches would enter the pub.

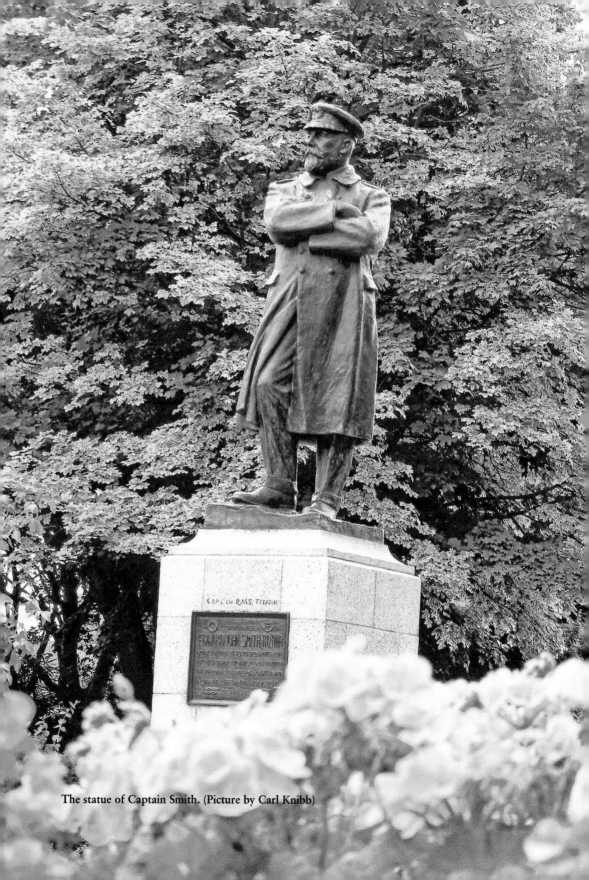

The statue of Captain Smith. (Picture by Carl Knibb)

41. Statue of Captain John Smith

In Beacon Park, just in front of the tennis courts, stands a statue of the captain of the *Titanic*, Edward John Smith. The statue is just under 8 feet tall and was sculpted by Lady Kathleen Scott.

Capt. Smith is shown in his uniform of the Royal Naval Reserves and the inscription on the plaque beneath reads:

Commander Edward John Smith, R.D., R.N.R.
Born January 27. 1850. Died April 15. 1912.
Bequeathing to his countrymen the memory and example of a great heart and a brave life
and a heroic death.
Be British.

It was sculpted by Lady Kathleen Scott, widow of Robert Falcon Scott, the celebrated 'Scott of the Antarctic'.

At the time of the *Titanic* tragedy on 5 April 1912, Capt. Smith was sixty-two years old and was the White Star Line's most experienced captain, earning £1,250 a year – a considerable sum in 1912. His captaincy of the *Titanic* was to be his last official duty before his planned retirement.

On the night that the *Titanic* struck the iceberg, Capt. Smith and his officers lowered the lifeboats and famously evacuated the women and children first.

Quietly resigned to going down with his ship and fighting to save as many as they could, Capt. Smith told Edward Brown, a first class steward, 'Well, boys, do your best for the women and children, and look out for yourselves' before walking onto the bridge before the *Titanic* took her final plunge (as reported in the British Wreck Commissioner's Inquiry of 1912).

Despite saving 705 passengers, 1,500 perished in the icy waters, including Capt. Smith whose body was never recovered. Stories persist that the captain survived long enough to help children stranded in the icy seas to a lifeboat, before pushing himself back out into the blackness to die.

Although Capt. Smith was born in Hanley, Stoke-on-Trent, it is thought that perhaps the people of Stoke did not wish to be associated with such a terrible disaster. The memorial statue has been a much-loved landmark in Lichfield since it was unveiled in 1914.

42. Causeway Bridge

This well-used bridge now brings traffic from Beacon Street in and out of the city, but this has always been a busy route. To the east you will see Minster Pool and to the west is an entrance to Beacon Park. The statue of Edward VI now stands on the spot where the Bishop's Fish Pool used to be, providing the bishop and his staff with fish to eat on the many days of the ecclesiastic calendar when meat was forbidden.

This watery spot could be crossed by a muddy causeway that would have been treacherous and unreliable for much of the year. It was therefore spanned by a causeway

The Causeway Bridge.

bridge in 1300. In 1816, Joseph Potter Snr built a new bridge, erected over the remains of the original structure.

This bridge was sturdily built using ashlar and cast iron, with a design incorporating three blind, elliptical arches on the Minster Pool side. It also features pointed cutwaters and roll moulding, and parapets with iron railings stop pedestrians from tumbling into the duck-filled waters below. Four openwork squares and lamp standards to each end complete this pretty nineteenth-century addition to the city.

A plaque on the northern side of the bridge reads:

> Under and extending along this pavement are the remains of the great bridge built over the vivarium by Bishop Walter De Langton (1296 to 1321). It lies about four feet below the pavement level. Consists of seven arches and is seven feet in width.

43. Garden of Remembrance

Sitting on land adjacent to The Close, the remembrance gardens are a response by the people of Lichfield to the terrible griefs of the First World War. The memorial depicts the

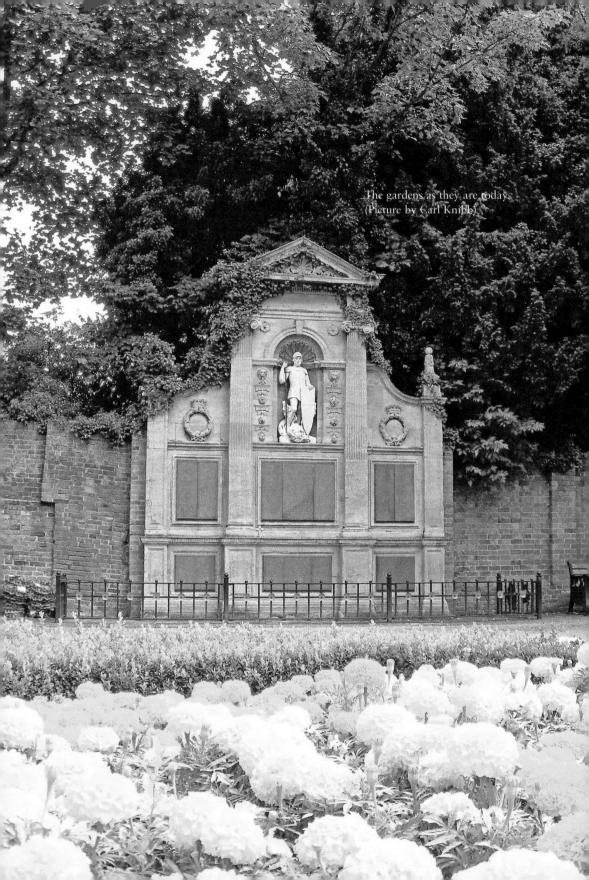

The gardens as they are today.
(Picture by Carl Knibb)

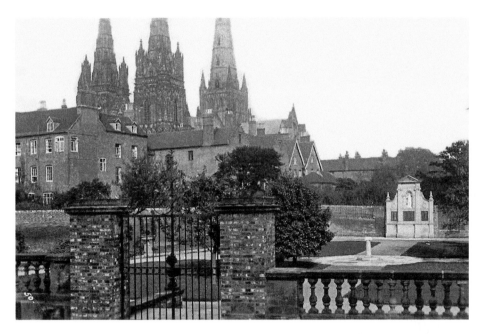

The Gardens of Remembrance *c.* 1924. (Postcard from the collection of David Gallagher)

figures of St George and the dragon, sculpted in Portland stone by the world-renowned stonemasons firm of Robert Bridgeman & Sons. It was designed by architect Charles Edward Bateman.

The garden was first laid out in 1919, with both the stone lions on the gates and the eighteenth-century balustrades allegedly coming from local great country houses. The gardens held their dedication ceremony in 1920. Subsequent wars have necessitated the adding of additional panels. Remembrance ceremonies still take place here every year and it is a favourite spot for wedding photographers, snapping couples just married in the registry offices opposite.

As you leave the gardens, the eagle-eyed will notice a strange lozenge-shaped stone set into the front of the right (south) gate post. It was discovered when the gardens were being constructed and is reputed to be a medieval (or earlier) boundary stone, marking the outer edge of The Close. To me, it looks like a cross surmounted by a low, squat, thatched building. In the Middle Ages, many could not read and so pictures were used to signify many things – shops showed images of their wares from overhead signs, as writing 'glover' or 'baker' would have meant nothing to most of their customers. Is this memorial gardens stone a pictorial representation of 'God's House'? And if so, is this an early image of the first Norman or earlier reincarnation of the cathedral, now long gone?

44. Angel Croft Hotel

Number 3 Beacon Street (or the Angel Croft Hotel as it's still popularly known in Lichfield) is an imposing Georgian building, opposite the Cathedral Close. Sadly now in a state of some disrepair, the Angel Croft was built in the 1700s by a local wine merchant, George

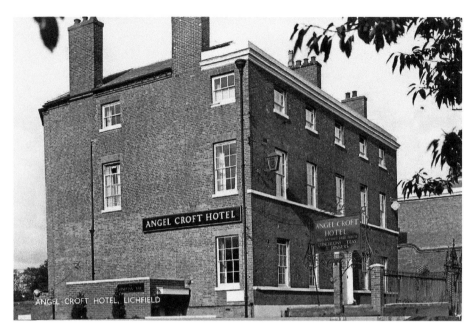

Above: The Angel Croft Hotel in the *c.* 1950s. (Postcard from the collection of David Gallagher)

Below: Angel Croft Hotel today. (Picture by Carl Knibb)

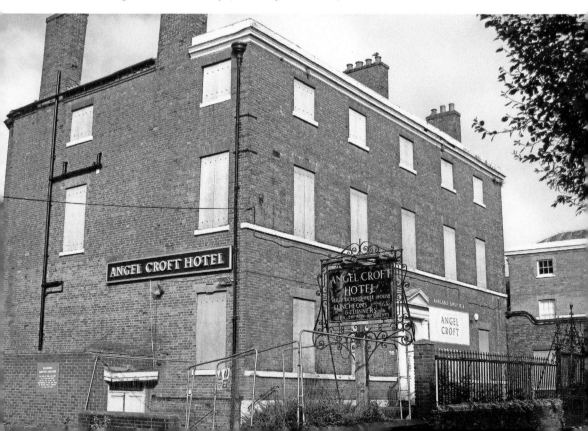

Adams – business must have been very good! It's possible that the Angel Croft stands on the site of the old Angel Inn, built itself on the site of the Lamb Inn.

Beacon Street has been an important street since the Middle Ages. The house is Grade II listed, and it has architecturally important features, including the front railings and gates that date to 1750 (which miraculously escaped the fate of so many of Lichfield's iron railings that were rooted up to provide metal during the Second World War). More recent predations saw the lead from the roof stolen. The Angel Croft's future remains unclear, with some suggestion that it may be turned into flats. As yet, there has been no firm confirmation of this.

45. Dr Milley's Hospital

The almshouse known as Dr Milley's hospital was probably founded in 1424 on a piece of land gifted by Bishop Heyworth. This strip of land was in the city's ditch and still sits several feet below street level.

Set up to offer accommodation to the poor, in the fifteenth and sixteenth centuries, the almshouse was endowed with property and land on Beacon Street, Sandford Street and in Kings Bromley, and the Cathedral Chantry also gave monies towards its upkeep.

In 1502–04, Thomas Milley, a canon residentiary at the cathedral, rebuilt and re-endowed it, and it has been known as Dr Milley's Hospital ever since. Dr Milley's supported and

Dr Milley's Hospital. (Picture by Carl Knibb)

accommodated fifteen almswomen who lived in the hospital and received a small income. Dr Milley's is a mirror to St John without the Barrs.

Dr Milley's is now governed by a board of trustees and the hospital is home to eight female residents. Careful and painstaking renovations in the early 1900s adapted what were somewhat crowded medieval spaces into more modern accommodation. Services are still regularly held in the beautiful on-site chapel.

Much of the original early sixteenth-century building still stands. The ancient stone doorway and porch reflects the size and shape of the chapel that sits above it. The interior still shows its dark ancient beams with close-studded timbering and late sixteenth-century doors. Each of the resident's apartments now contains kitchens and en suite bathrooms, a far cry to what their medieval counterparts would have experienced.

A beautiful event known as the Rose Ceremony takes place every June where a resident presents the bishop with a posy of roses.

46. The Pinfold

For centuries, Lichfield held regular livestock markets. Inevitably, these animals would sometimes escape en route and would cause havoc until they could be claimed by their

One of Lichfield's historic pinfolds. (Picture by Carl Knibb)

owners. The problem was how to contain lost animals and keep them out of mischief until their owners arrived to pay a small fine for allowing them to wander. To solve the problem, Lichfield had several pinfolds, small walled spaces that would keep lost livestock out of mischief. By the mid-seventeenth century, Lichfield had two 'pinners' (wardens responsible for rounding up and containing lost animals).

The fantastically preserved and rare pinfold on Pinfold Road (just where Beacon Street becomes Stafford Road) has listed status and dates from the mid-eighteenth century.

47. Erasmus Darwin House

Erasmus Darwin House was, as the name suggests, home to Dr Erasmus Darwin, another literary star of his day and a fascinating man. Erasmus was a highly regarded physician, poet, inventor and botanist. He is the grandfather of Charles Darwin and was in fact the first in the family to explore the idea of natural selection. He moved into what is now Erasmus Darwin House (a museum dedicated to the great man) in 1758.

Here, he became centre of a network of great enlightenment thinkers. He was also a founding member of the Lunar Society, a group that included Josiah Wedgwood, James Watt and Matthew Boulton. The group would meet to discuss the great scientific matters of their day.

Erasmus' inventions include a speaking machine and a copying machine, both very advanced for their period. He was, in short, a 'Renaissance man', a good friend and a kind man whose interests and talents were far-reaching.

The current house was built in two stages and straddles the line where The Close's defensive wall would have been. There are still parts of this wall in the cellars. The three original thirteenth-century buildings (at least one of which was a bakery) that stood on this site were on the inside of and built up against the wall. In the sixteenth and seventeenth centuries, these three small houses were replaced by a half-timbered house, very like No. 3 Vicars Close in construction. We know that the houses would have been similar, because when Erasmus Darwin House was converted to incorporate a lift shaft, timbers reclaimed from the early house were found, and some were identical to those of number three. In fact, they could well have been constructed by the same builder. It was this half-timbered house that Erasmus Darwin moved into.

However, this house was too old for such a forward thinker. He therefore added light, spacious Georgian rooms and a Palladian facade to the front of the house (facing Beacon Street). The front of the building became a modern 'top spec' town house where he could entertain his guests and see his patients.

Eventually, Erasmus and his family moved to Derbyshire and the lease of the house was taken over by his brother-in-law, Charles Howard. Charles decided to sweep away the half-timbered building that remained at the back of the house, converting the whole to the Georgian building we see today.

If you have the opportunity to visit the cellars, they'll give you a real idea of how the house developed. To the front of the house these cellars are in fact Georgian rooms at ground-floor level. The cellars to the back of the house are twelfth or thirteenth century and part of the original dungeons. It is here that you can see parts of the original Close

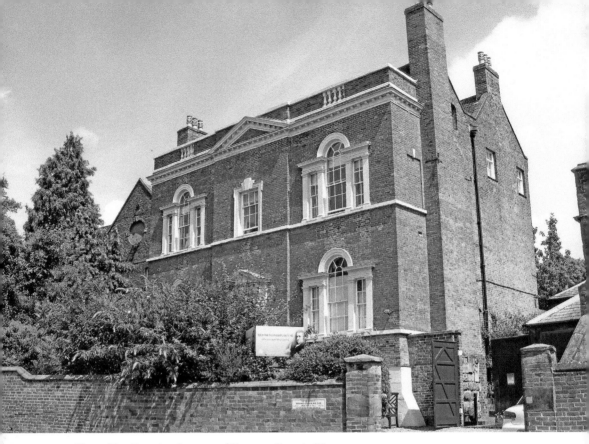

Above: The Georgian frontage of Erasmus Darwin House.

Below left: Interior of Erasmus Darwin House.

Below right: The medieval cellars in Erasmus Darwin House, showing the stone where cadavers may have been kept before dissection.

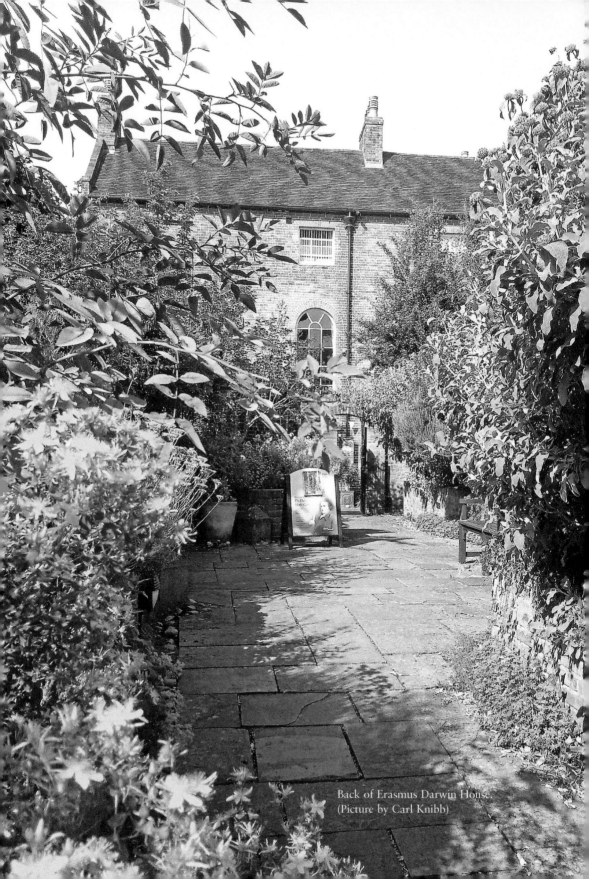

Back of Erasmus Darwin House.
(Picture by Carl Knibb)

defensive wall and it is also here that Erasmus probably stored the cadavers of criminals, ready for them to be dissected in front of his colleagues in the rooms upstairs.

To the south side of the house is the old coach house and a brick-built ramp, built so that Erasmus' horse could get up the slope. The front of the house is built into the dry moat or ditch.

In Erasmus' day, to enter the house through the main door, visitors would pass over a Chinese-style bridge, built across the dry moat in front of the house (the double flight of steps are a more recent addition). Beneath this door was the servants' entrance and to the left was a separate private entrance for patients. The house holds a Georgian cantilever staircase, one of only three in the country. Outside, you'll see a culinary and medicinal herb garden.

Author's note to the reader: By this point in your tour, you will have walked in an approximate circle, bringing you back to your starting point at the Cathedral Close. The next destinations on the tour are just outside of easy walking distance.

48. Sandfields Pumping Station

It's no exaggeration to say that Sandfields Pumping Station is responsible for the saving of thousands of lives.

In 1832, the Black Country was hit by a virulent outbreak of cholera, a disease spread by drinking dirty water. In six weeks, well over 2,000 people died. In 1848, cholera struck again, claiming thousands more. Something had to be done.

Sandfields Pumping Station. (Picture courtesy of David Moore)

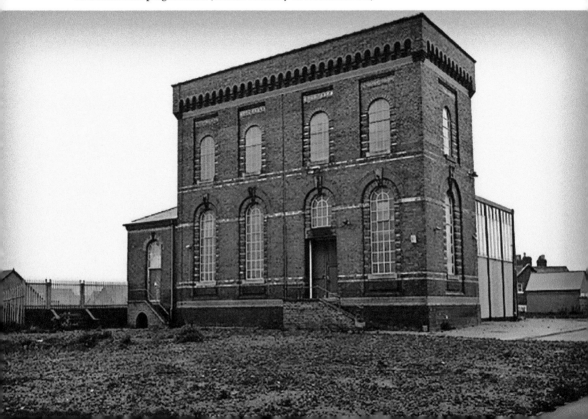

In Lichfield, Staffordshire Waterworks Co. was formed as a response to the need for clean and plentiful water. Four million gallons of water a day were pumped by Sandfields Pumping Station.

The building is internationally important, not least because it still houses a unique 190-horsepower Cornish beam engine, built by Jonah and George Davies of Tipton. Installed in 1873, it ran until 1927. The Lichfield Waterworks Trust is now in the process of moving towards the long-term securing of Sandfields and its beam engine. Sandfields Pumping Station is not currently open to the public.

49. St Bartholomew's Church, Farewell

Farewell Church is a little slice of heaven, sitting in a lush valley, fed by two streams bordered by watercress and forget-me-nots. This fresh water supply and sheltered position must have been important factors in the decision to site a nunnery here from the twelfth century, although a small monastic community and, before this, a Saxon settlement had also been on the site. There has been a church on the current site of St Bartholomew's since before 1140.

St Bartholomew's Church. *Inset*: One of St Bartholomew's ancient misericords.

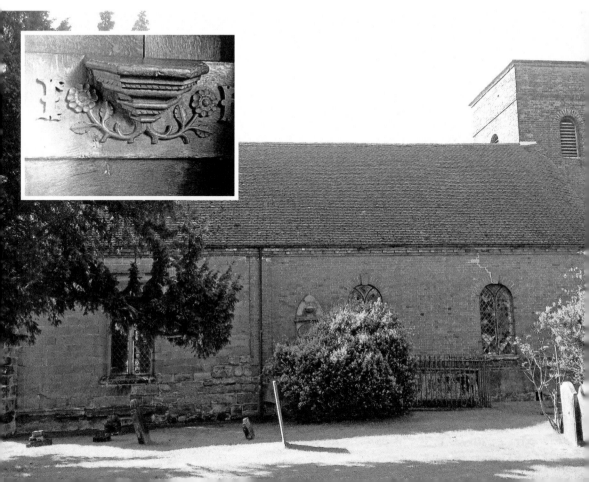

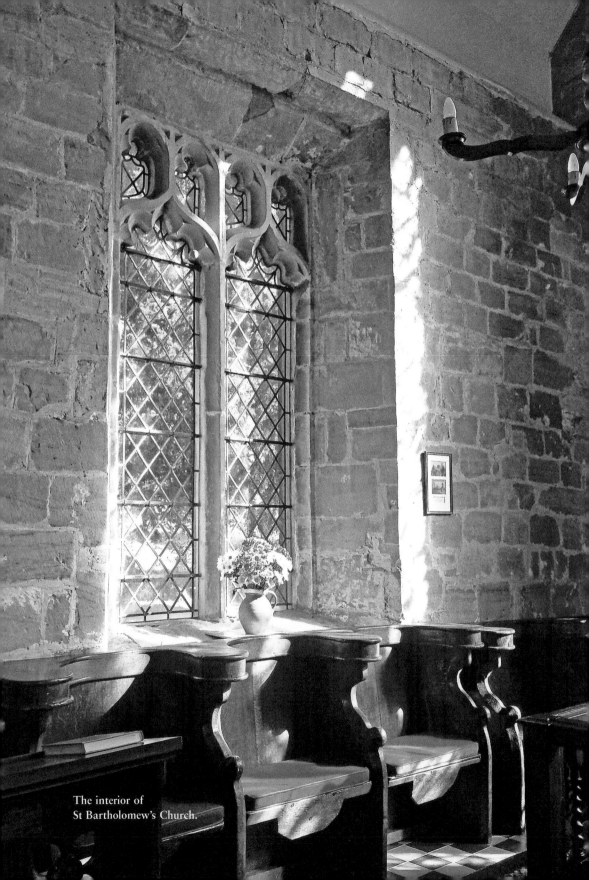

The interior of
St Bartholomew's Church.

In 1140, Roger, Jeffrey and Robert (three monastic hermits resident at Farewell), the Chapter of Lichfield and the Bishop, Roger de Clinton, gifted the prime site for the creation of a Benedictine nunnery, the remains of which are still evident in the lumps and bumps in the field behind the church. Included in this generous gift was a mill, and in fact if you stand behind the church, you can see the mill and the millpond glinting silver in the distance.

By the fourteenth century, as was not unusual at the time, there were rumours of scandalous behaviour at the nunnery.

The lane that leads to St Bartholomew's is called Cross in Hand Lane, which may refer to the crosses held in the hand of pilgrims seeking accommodation on the way to visit St Chad's shrine at the cathedral. Cross in Hand Lane was in fact the main road from Stafford to Lichfield right up until 1770. Although St Bartholomew's is now a quiet country church, it would have been vitally important to thousands of medieval pilgrims, walking towards the cathedral, just a mile or so away. Stand here and you have an idea of how many medieval men and women first approached the city.

The east end of the church dates from the fourteenth century onwards, with perhaps some earlier survivals. The west end was reconstructed in the eighteenth century, as it was in a terrible state of repair. When the north wall was taken down, several pots were found secreted in the wall. What they were for and what they contained, if anything, remains a mystery.

The nave dates from 1740, with the tower added in 1747. The tower still contains three bells, one of which dates to 1527 and the others to 1602. This is the remarkable thing about our ancient church bells, through them you can hear a sound that has changed very little for 500 years.

If you visit the church, look out for the small bricked-up door on the south wall, believed to be where the priest entered when the church was attached to the nunnery. Another beautiful survival is the set of thirteenth-century misericords, one of which is carved with the letters 'ER', believed to be the initials of the prioress.

In the middle of the nineteenth century, the church was renovated and given a new roof, and in 1826 the large yew in the churchyard was planted. Just outside the churchyard wall you'll find one of the original medieval fish ponds and to the west the remains of the Saxon spring and well.

50. Letocetum Roman Site, Wall

It may seem strange to include Wall in a book on the City of Lichfield, but the pretty little village of Wall, 1.5 miles from central Lichfield, played a significant part in the development of the early city.

In the village of Wall are the remains of Letocetum, a Roman staging post on the import Roman routes of Watling Street and Ryknield Street. A cross between a modern motorway service station and a civic administration centre, Wall offered all of the comforts that a weary soldier, official, merchant and traveller could want. Here, you'll find the ruins of the Mansio (guest accommodation) and the Bath House, although the uneven nature of the surrounding ground hints at much more. Letocetum was created very early in the Roman occupation of Britain in AD 50 and, in the next fifty years, the original fort was joined by a small town that sprung up around it. As the settlement

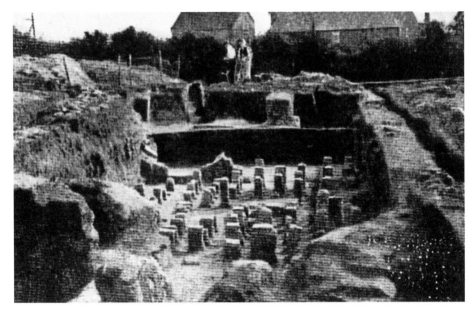

Above: The hypocaust at Wall, 1953. (Postcard from the collection of David Gallagher)

Below: The Letocetum today.

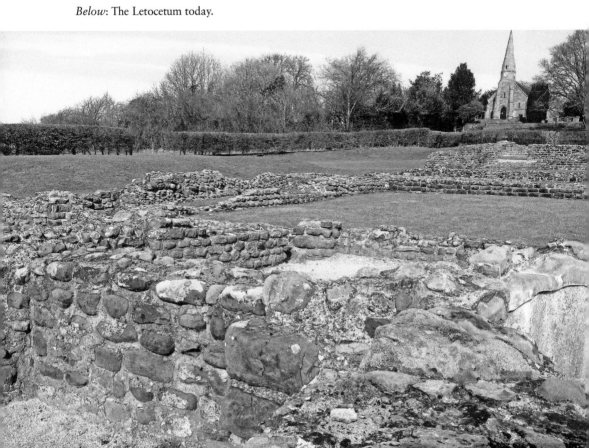

developed (to eventually cover 30 acres), it spread down both Watling Street and the crossroads at Ryknield Street. This quiet spot may in fact be the site of the Battle of Watling Street, where the fourteenth legion defeated the forces of the Iceni tribe under Queen Boudicca.

The Bath House comprised of an exercise room (similar to a modern gym). To enter the baths, bathers would have undressed in the changing room, leaving their belongings on numbered pegs or alcoves, taken a plunge into the cold bath, moved into the warm rooms (perhaps rather like a sauna) and then into the hot bath. They'd then reverse the process, ending up back in the changing rooms. The existing rooms, and the remains of the hypocaust (underfloor heating system) can still be seen.

The Mansio consisted of four wings of rooms with a central courtyard – providing stabling, food, rooms and a pleasant central spot out of the wind and open to the sky, to relax, chat, and do business.

Wall's Roman site is quite remarkable and well worth a visit when the small but fascinating on-site museum is open. It contains stones that are carved with Celtic pigtailed warriors and seems to depict a story from some now sadly lost heroic saga. Within the Roman walls of the site, a strange Celtic carved head was also found. It had been placed into the wall facing inwards. Was this an icon of a Celtic God left over from a pagan site at Wall overrun by the Romans? Was it turned to face the interior of the wall to contain any troublesome spirits that might inhabit it?

Bibliography

Barnard, Tony, *Lichfield Cathedral*, (Andover: Pitkin Guides, 2001).

Barron, C. M. and Harper-Bill, Christopher (eds), *The Church in Pre-Reformation Society* (Woodbridge).

BBC News.

Benson, Larry and Robinson, F. N. (ed.) *The Riverside Chaucer* (Oxford University Press).

Birmingham Mail.

Board of Trade, 'British Wreck Commissioner's Enquiry: The Loss of the SS *Titanic* USA' (1912).

Bond, W. G., *The Wanderings of Charles I* (Cornish Brothers Ltd, 1935).

British-history.ac.uk.

British Listed Buildings.

Brown, Mike, *Living Brewery History.*

Burntwood Family History Group.

Burton-on-trent.org.

Bygonederbyshire.co.uk.

Carpenter, Revd, *St Michael's Church Lichfield: A Short History* (Lichfield: JAC Baker, 1982).

Cinematreasures.org.

Charnwood, Lady (Dorothea), *An Autograph Collection and the Making of It* (London: 1930).

Clarke, Ian S., *Behind 'Close' Doors* (Lichfield: Erasmus Darwin House, 2008).

Clayton, Howard, *Cathedral City* (Clayton, 1981).

Clayton, Howard, *Coaching City* (Clayton).

Clifford, Sue and King, Angela, *England in Particular.*

Coley, Neil, *Lichfield Stories* (The Lichfield Press, 2013).

Coley, Neil, *The Lichfield Book of Days* (2014).

Comerford, Patrick. www.patrickcomerford.com.

Drury, P., *The Capitular Estate of Dean and Chapter of Lichfield Cathedral* (1987).

English Heritage (English-heritage.org.uk).

Falconer, Revd Dr J., *South Staffordshire Archaeological & Historical Society Transactions, Volume 12* (1970–71).

Gomez, Kate, *Lichfield Lore* (lichfieldlore.co.uk).

Gould, D. and Gould, J., 'St Michael's Churchyard, Lichfield, Staffs' (Staffordshire Archaeological History Society, 1974–75).

Greenslade, M. W. (ed.) *A History of Lichfield, Part I. An extract from the Victoria County History of Staffordshire Vol XIV* (Staffordshire Libraries, Arts and Archives, 1990).

Greenslade, M. W. (ed.) *A History of Lichfield, Part III. An extract from the Victoria County History of Staffordshire Vol XIV* (Staffordshire Libraries, Arts and Archives, 1990).

Greenslade, M. W. (ed.) *A History of the County of Stafford: Volume 14: Lichfield* (1990).

Greenslade, M. W. (ed.) *The Victoria County History of Staffordshire, Volume 14* (Lichfield, Oxford: 1980).

Greenslade, M. W. and Pugh, R.B. (eds) *The Victoria County History of Staffordshire, Volume 3* (London: 1970).

Harwood, Thomas, *The History and Antiquities of the Church and City of Lichfield.*

Hind, Philip, et al, *Captain Edward John Smith* (Oxford: Encyclopedia, 2013).

Horn, Joyce M. (ed.) 'Canons residentiary of Lichfield,' *in Fasti Ecclesiae Anglicanae 1541- 1857, Volume 10: Coventry and Lichfield Diocese* (2003).

Hutchinson, M., Croot, I. and Sadowski, A., *This Won't Hurt: A History of the Hospital of Lichfield* (2010).

Kettle, A. J., 'City and Close: Lichfield in the Century before the Reformation.'

Learningwitharchives.org.

Lichfield-catherdral.org.

Lichfield Discovered.

Lichfield District Council.

Lichfieldgarrick.com.

Lichfieldgov.uk.

Lichfield Mercury.

Leighfield, E. J., *The History of St Michael's Hospital* (Lichfield: 1978).

Localhistories.org.

Lomax, T. G., *A Short Account of the Cathedral of Lichfield* (Lichfield: Lomax, 1831).

Marston, F., *The 'Hate' House* (Lichfield, Staffs).

Moore, David, Lichfield: The Gift of Clean Water, Sandfields Pumping Station.

Oxford Dictionary of National Biography.

Pevsner, Nikolas, *Staffordshire* (London: Penguin, 1974).

Rawlinson, Dr, *An Inquiry into the History and Influence of the Lichfield Waters: intended to show the Necessity of an Immediate and Final Drainage of the Pools* (1840).

Robert, Marion, 'Close encounters: Anna Seward, 1742–1809, a woman in provincial cultural life' (University of Birmingham, www.patrickcomerford.com, 2010).

Rodwell, W., *St Mary's House: Provisional Account of its Architectural History* (1988).

Rubery, Annette, *Lichfield Then & Now in Colour* (Stroud: The History Press, 2012).

Salloways.co.uk.

Salter, Mike, *The Old Parish Churches of Staffordshire* (Folly Publications, 1996).

Samuel Johnson Birthplace Museum & Bookshop Souvenir Guide.

Savage, H. E., *Thomas Heywode, Dean*, (Lichfield: 1925).

Scaife, Patricia, *The Carvings of Lichfield Cathedral* (Much Wenlock, Shropshire: RJL Smith, 2010).

Scaife, Patricia and Moore, Anthony, *Lichfield Cathedral* (Scala Arts & Heritage Publishers Ltd, 2014).

Shaw, John, *The Old Pubs of Lichfield* (2001).

Shaw, Stebbing, *History and Antiquities of Staffordshire* (1798).

Simkin, D.J., *A Guide to Some Staffordshire Churches* (Curlew Countryside Publications, 1983).

Southworth, Carol M., 'Pluralism and Stability in the Close, The Canons of Lichfield Cathedral in the Last Quarter of the Fifteenth Century,' (University of Birmingham, www.patrickcomerford.com, 2012).

Spooner, I. *The Journal* (1969).

Staffordshire County Council.

Stchadscathedral.org.uk/cathedral/interesting-facts.

Stchads.weebly.com.

Stjohnslichfield.com.

Stmaryslichfield.co.uk.

St John Hope FSA, W. H. *The Journal of Derbyshire Acheological Society.*

Sutton Coldfield Observer.

Tamworth Herald.

Thegeorgelichfield.co.uk.

Titanicmemorials.co.uk.

Tudorrow.com.

Upton, Chris, *A History of Lichfield* (Phillimore & Co Ltd, 2001).

Visitlichfield.co.uk.

Walker, Peter N., *The Story of the Police Mutual Assurance Society* (1992).

William Salt Society (ed.) *Collections for a History of Staffordshire 1886, Part II, Vol VI.*

Workhouses.org.

You're Probably from Lichfield, Staffs if …

Acknowledgements

Researching and writing this book has been a pleasure. Without doubt it would not have been possible without the guidance of several local historians who have all been incredibly generous with their help and advice – my especial thanks to Kate Gomez, Joanne Wilson, David Moore, David Gallagher, Steve Johnson and Revd Canon Professor Patrick Comerford. My sincere thanks must also go to the many kind souls who took the time to show me around their homes, churches and places of work. I hope that I have done our city justice.

Finally, I'd like to thank the many individuals who, over seven years of chance encounters, have pointed out some of the hidden historical glories of this city and area. From quiet, ancient hollow-ways to holy wells and standing stones – my jaw has dropped on more than one occasion.

Our ancient buildings are an important national asset. They may be draughty, not up to modern standards and generally a challenge to maintain and preserve, but they will pay us back twelvefold if we care for them and pass them on to our own children. Lichfield is home to a robust group of local historians who love and cherish our city. The work that you do is vitally important, and yet in many cases it's unpaid and simply done 'for the love of it'. Thank you for honouring the past of our city, and for speaking up for a world that is silent but with us still.

A winter sunset on The Close. (Picture by Carl Knibb)

About the Author

Joss Musgrove Knibb has been interviewed as a local historian on Sky TV, ITV and by the Press Association (the interview was then broadcast in India, Australia etc.). She has spoken at the Lichfield Literary Festival and the Stoke Literary Festival where she was asked to speak alongside Michael Palin, Andy McNab, Alistair Campbell and Margaret Drabble.

Joss has been interviewed by Touch FM, Signal FM and many others including BBC Radio Stoke & Staffordshire. She has recorded two history features with BBC Radio Stoke that were serialised over several weeks. She has spoken all over the country, including a lecture at the National Memorial Arboretum at the Birmingham Lord Mayor's Show in 2015.

Joss' book *First Lines* was chosen as a 'WH Smith Recommends' book. She is a professional journalist (editor of *Citylife in Lichfield* magazine) and has written features for the *Stoke Sentinel*, *Lichfield Mercury* and *Staffordshire Life*. Joss has been quoted in *The Times*, *The Guardian*, the *Daily Mail* and many others.

Joss lives in Lichfield with her family. She is fascinated by the history of those people that tend to go unrecorded – the agricultural labourers, servants, thieves, rogues and vagabonds whose lives are so often filled with event and drama, but who might leave very little behind them.